HISPANICS *of*
Roosevelt County, New Mexico

HISPANICS *of*
Roosevelt County, New Mexico
A HISTORY

AGAPITO TRUJILLO

Foreword by Dr. Donald C. Elder III

THE
History
PRESS

Published by The History Press
Charleston, SC 29403
www.historypress.net

Copyright © 2015 by Agapito Trujillo
All rights reserved

First published 2015

Manufactured in the United States

ISBN 978.1.62619.915.6

Library of Congress Control Number: 2014958078

There are so many people who contributed to my efforts to put my words and thoughts on paper that I could write yet another volume expressing my gratitude. Having said that, I want to expressly dedicate my endeavors to the main group of people who began the adventure with me: my parents, Abel and María Soledad; my sisters Rita Ruiz and Sandra Salguero; and my brothers Abel Jr., José Armando and León. Last but not least, thank you to George, who began and was a large part of my adventure, not only as brother but also as a constant (and for many years my only) companion. George's life was cut short by a coward's bullet on the streets of Lubbock, Texas. Sadly, he didn't get to realize the fruits of our struggles. In addition, I am grateful for the support from my wife, Amelia, and five daughters—Dina, Munci, Christine, Lorraine and Kim—who bore the brunt of the criticism for my actions as a police officer. In addition, thank you to the many friends and contacts on social media, such as Facebook, who encouraged me in my effort to put my memories into print. Last but not least, thank you to two persons not mentioned by name in the text: my sister Juanita Trujillo, who contracted polio at an early age and did not make the journey to Roosevelt County with us but remained with grandparents in the Santa Fe area, and León Trujillo, who was the last member born into our family and was part of the adventure.

Contents

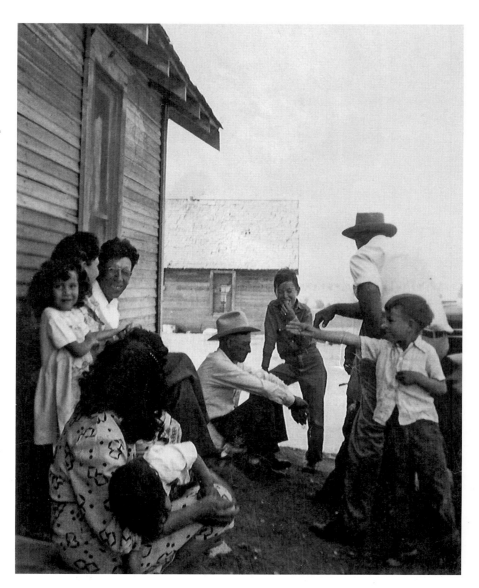

Trujillo family group. *Author's collection.*

Foreword

In 1540, a Spanish conquistador named Francisco Coronado led an expedition from Mexico into what is now the state of New Mexico. From that point on, New Mexico has had a definite Hispanic flavor to it. Indeed, New Mexico is today the only officially bilingual state in the Union.

Because of the efforts of Coronado and other like-minded Spaniards, the Spanish language has been heard in the region for well over four hundred years. Although this means that Spanish-speakers have composed a significant portion of the area's population since Coronado's time, this fact did not always translate into those individuals being accepted within the boundaries of what would become the state of New Mexico. The original inhabitants of the area, for example, resisted Spanish incursions into their homeland, most famously in the Pueblo Revolt of 1680. While the Spanish were eventually able to reassert their authority in New Mexico, hostilities would occasionally continue to flare up between the original inhabitants and their putative rulers.

The original resistance of the natives of New Mexico to those who spoke Spanish is understandable to us in today's day and age, as those inhabitants were merely trying to protect their homeland. But unfortunately, a much more insidious resistance to Spanish-speakers would also plague New Mexico; many of the individuals who moved to the Southwest when the United States gained control of the area after the Mexican-American War brought with them a prejudice against Hispanics that would mar relations for many years thereafter.

FOREWORD

It was into this world that Agapito "Pete" Trujillo was born seventy-seven years ago. Growing up in Portales, New Mexico, he faced both prejudice and discrimination. A stint in the United States Marine Corps seemed to make no difference to the non-Hispanics in his hometown. His is a story that is all too familiar to people with Spanish surnames residing in the Southwest.

At this point in his life, Pete could have been forgiven for becoming bitter toward the society that shunned him for his background. Fortunately, that was not Pete's nature. Believing that he could make a positive change for himself and others like him, he chose to try to change people's perceptions by actively engaging in his community. To this end, Pete became the first Hispanic law officer in his community and later became one of the first Hispanic schoolteachers in Portales. When he encountered latent prejudice, as he did when attempting to become a school administrator, Pete always chose to simply let his record for honesty and integrity speak for itself. In this manner, Pete prepared the way for other Hispanics to rise in the hierarchies of Portales, a process that culminated in 1998 with the election of the city's first Hispanic mayor.

It has been my great pleasure to know Pete for twenty years now. I have found him to be a man who cares about the members of his community, regardless of their background. He truly believes that New Mexico can be a model for the rest of the nation, and he decided that, by telling his story, he could help move the nation toward a better cultural understanding. I was honored when he asked me to write a foreword to his book. Pete has been an inspiration to me, and I hope I have done justice to both him and his tale of cultural transformation.

DR. DONALD C. ELDER III

Acknowledgements

I am grateful to the many people who encouraged me to write this narrative and am especially thankful for the resource people who contributed their time and expertise. Thank you to Gene Bundy and Debbie Lang at Eastern New Mexico University Golden Library Special Collections, for helping me with the acquisition and scanning of images included in this volume; Shirleen Peters, Secretary Department of Fine Arts Eastern New Mexico University, for taking time from your busy schedule to read my initial attempt at writing; "Doc" Donald Elder, professor of history at Eastern New Mexico University, for also taking time to read my manuscript, provide words of encouragement and write the foreword for my work; and my wife, Amelia, for being patient and supportive during your hours of isolation while I was writing. Also, a special note of gratitude goes to Christen Thompson, my commissioning editor at The History Press, without whose guidance and expertise this book would have never been launched.

Prologue

The following is not intended to be a "poor little ole me" sob story, for I have learned that regardless of how poor a person says he was, the next person can always come up with a better story.

That we were poor goes without saying. We didn't have the proverbial pot or window to throw it out of, but we didn't know it. To me, it was an adventure that continued throughout my life.

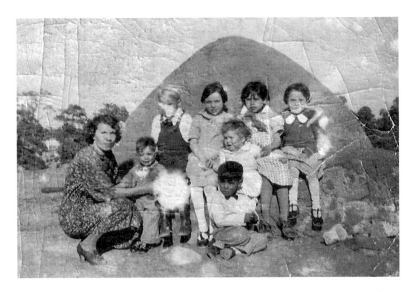

María Soledad Trujillo, while living at La Palma, posed in front of a functional horno, which are used for baking. *Author's collection.*

I am writing this in the first person because it is how I remember it. Sometimes, I may leave something out and think of it later and insert it out of sequence. Some of the names may be misspelled, and for that, I apologize. I mean no disrespect to anybody, living or dead.

The recorded history of the Hispanic people in Portales is very sparse and incorrect. The Roosevelt County heritage book devoted a page or two.[1] My father was interviewed, as well as other people I write about, but I suppose because of the language barrier, not much appears in those books.

Perhaps I am putting the cart before the horse. I'll start from the beginning: I was five years old. The Encino area had been home since my family had migrated from a small rancho; we were always in search of employment. The Encino area at that time was largely a sheep-raising area. Drought devastated that industry, and earning a living became difficult. Encino, New Mexico, is a small village, seventy-three miles southeast of Albuquerque. The population is around seventy-five.

CHAPTER 1

The Journey Begins

One late summer morning, a truck appeared and began recruiting workers for farms in a land called "Portales." Even a small boy, they said, could earn good money in the fields. To impoverished people, this sounded like the land of milk and honey. Several families packed a few belongings, bedding, cooking utensils and little else. They loaded onto the stake truck, and their journey began.

The truck arrived in Portales late in the evening. My first glimpse of Portales was from the west side of the courthouse. From the back of the truck, I could see brightly colored lights and storefronts with people in them. I later learned that these were mannequins, the first I had ever seen. The Kiva movie theater was lit up, and people were moving about. But where were the peanuts? Where we were going to make all that money?

After a while, the truck began moving, and we were taken to an area where there were large buildings, even a gazebo. All our belongings were dumped off the truck, and we spent that first night and several more nights under the stars. For the next few weeks, farmers would come by and pick up the men and some of the women to go work in the fields—there were melons, green beans and other vegetables but no peanuts. Our first residence in Portales was the open skies of the Roosevelt County fairgrounds. We were there for a number of weeks. There were several large buildings on the fairgrounds, along with a rodeo arena. The buildings were quite modern in that they had electricity and, I suppose, plumbing. But we only had access

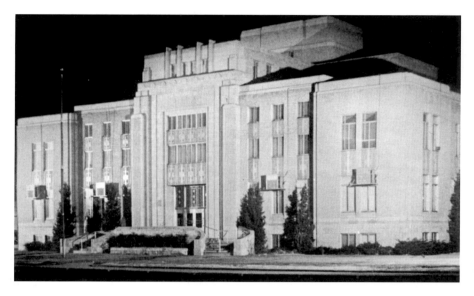

Roosevelt County Courthouse. *Courtesy ENMU Special Collections, Golden Library.*

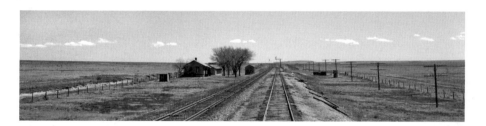

Rural Encino, New Mexico, not far from where we lived. *Courtesy of the Library of Congress.*

to the gazebo. Luckily, there was no rain or one of the terrible wind and sand storms that the area is notorious for.

Defining Portales defies the imagination. It is located on the eastern plains of New Mexico, around twenty miles from the Texas state line. Affectionately labeled "little Texas," the atmosphere, unlike the rest of New Mexico, is strictly Texan. The population speaks and acts Texan. Many people wear western attire—jeans, boots and broad-brimmed hats—and drive pickup trucks. In those days, before nicotine products became unpopular, almost every "cowboy" could be identified by the impression of a can of Skoal or Copenhagen smokeless tobacco in his hip pocket and a spit cup on his pickup truck's dash.

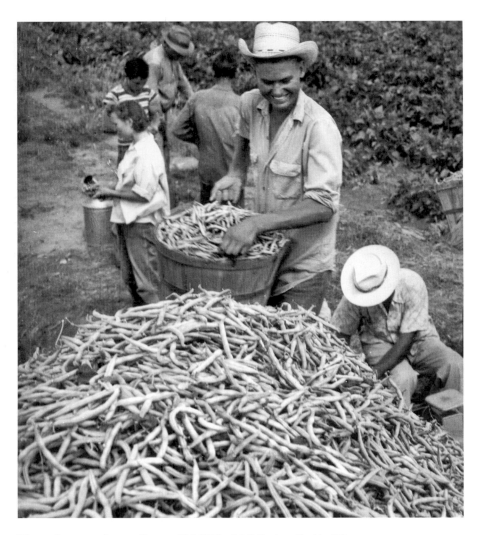

Harvesting green beans. *Courtesy ENMU Special Collections, Goplden Library.*

The town's cuisine in the period of which I write was strictly unlike the cuisine west of the Pecos River or along the Rio Grande corridor. There were no chilies, red or green. There were no Mexican restaurants. The nearest thing to Mexican food was a gentleman from Clovis coming to sell tamales from a pushcart (Roger's Tamales), this generally on Saturday.

Portales in those days was race conscious. Legend has it that it had been labeled a "sundown town." Sundown towns have been described as being intolerant toward African American citizens, to the extent of denying them

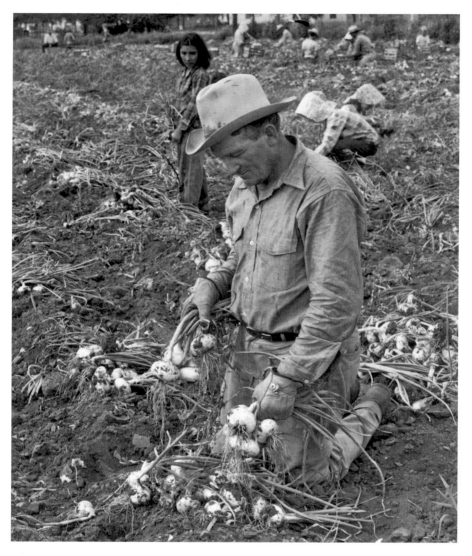

Harvesting onions. *Courtesy ENMU Special Collections, Golden Library.*

to remain within the confines of the community over night. In all of my research, I have been unable to obtain documentation to substantiate or negate the allegation that Portales was a sundown town.[2]

People coming to Portales from the slow, leisurely lifestyle of northern New Mexico were truly in for a culture shock.

Another undocumented rumor that has been passed down involves what was once a freshwater spring that fed into a good-sized lake, where

a windswept lakebed now sits. This is fact. It is from that lake and its outcropping of caliche rocks that Portales got its name. From a distance, the outcropping resembled porches. *Portales* is Spanish for "porches." What is legend is that, in the 1800s, William H. Bonney—alias "Billy the Kid"—used a small cave in that area as a hiding place for himself and cattle that he had stolen. The lake long ago became alkaline and is now a dry lakebed. It's still called "Portales Springs" or "Billy the Kid Cave."[3]

Now, back to my story:

After a few weeks, the farmers, through some device or another, decided to each take a group of families to their farms. Some of the farmers I remember were named Kenyon, Starr and Payne—others I don't remember. The farmer who took my family and several other families was A.G. Kenyon. There were probably five or six families, maybe more. We were housed in a granary that was around twelve feet wide and forty feet long. The building was located directly east of A.G. Kenyon's house. He and his wife lived there, in a dwelling I considered a mansion. To this day, I have never seen the interior of that house. It is still there, owned by Danny Horn. (I was promptly and rudely informed by the present occupants that Danny had not lived there for some time; but I assume all of that property is now held by the Horn family. Where the granary once stood, Charley Horn has built large metal, barnlike buildings and developed the former peanut fields into a residential area.)

Between that house and the granary were several rows of grapevines, which bore very beautiful and tasty fruit. They were off limits to us, but I won't go into that. Back to the granary. All the families were put in that building. Blankets hanging from the rafters separated families. There were three other buildings in the area: a red block building, in which tractors were housed; a small frame house, which was unoccupied; and a large, rust-colored tin barn. Later on that winter, my family, the only family who chose to tough out the harsh winter, moved into the small frame house. All the families lived in the granary throughout the harvest. I might add that every building on the grounds would have made better living quarters than the granary. After harvest, most chose to go back to Encino. Many never returned.

The actual harvest time was coming on and that's when we discovered that peanuts were planted in rows. Mr. Kenyon prided himself on having the longest, straightest rows in the county. They were one mile long. Each row would earn one dollar. The land of milk and honey was now turning into the land of backbreaking labor.

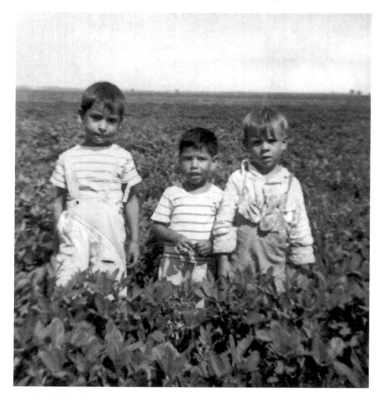

Left: (From left to right) Gabriel and Ruben Encinias and José Armando Trujillo in a peanut field. *Author's collection.*

Below: Early Roosevelt County courthouse. The fields that used to surround it are now gone. *Courtesy ENMU Special Collections Golden library.*

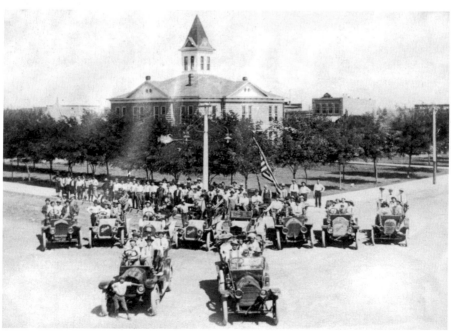

Harvesting windrowed peanuts. *Courtesy ENMU Special Collections, Golden Library.*

Describing the living conditions in those days is somewhat difficult because, in a five-year-old child's eyes and mind, the adverse conditions were more of an adventure. The granary that we lived in provided little privacy. The quilt-partitioned twelve-by-twelve space allotted to each family was scarcely enough for a mattress during the night and a small three-burner kerosene cookstove.

The stove was a very primitive-looking device: three burners situated on a half-inch pipe with a glass bottle and a valve mechanism. The bottle was turned

Turning up peanuts for hand shocking. *Courtesy ENMU Special Collections, Golden Library.*

upside down and kerosene flowed by means of gravity through the pipe and saturated asbestos and cardboard wicks at each burner. A knob was used to somewhat adjust the flow to regulate the amount of heat. Cooking on these was quite a chore, but the women somehow managed to prepare complete meals. These stoves were the only appliances that we had.

Sleeping accommodations were largely resolved depending on the weather. In the dry, hot New Mexico summer, everybody slept under the

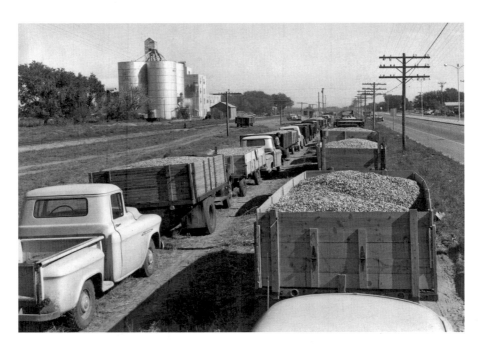

Peanuts awaiting processing at Portales Valley Mills, owned by later New Mexico governor John Burroughs. *Courtesy ENMU Special Collections, Golden Library.*

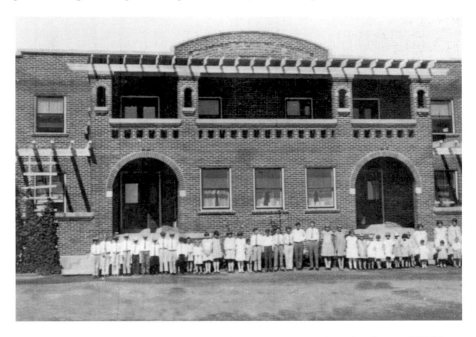

First dormitory and building of the Baptist Children's Home in Portales. *Courtesy ENMU Special Collections, Golden Library.*

stars. Rain in those days was rare. Drought conditions existed throughout the Southwest, so sleeping outside was not a problem.

With several families living under the same roof, it is difficult to imagine why there was not some sort of cafeteria method of dining set up. But there wasn't. Every family did their own cooking, although the diet was meager, consisting mainly of pinto beans, potatoes, tortillas (homemade) and little else. There were no luxuries for these immigrants to a foreign town, a sparse few miles from their original home.

World War II had begun with the bombing of Pearl Harbor. Many of the young men who were old enough had volunteered to serve in the military. This had caused a shortage in the available workforce. In addition, wartime rationing of fuel and tires, as well as farming implements, made it necessary to use manual labor, especially in agriculture.

CHAPTER 2

Portales

Portales in 1942 was unique in that the population was totally Anglo, or white. Prior to my family's arrival, there were no permanent Hispanics, blacks or any other minorities. Later historians maintain that there was a family of Hispanic origin residing in the community some years earlier. That family, surnamed Carrasco, supposedly attended school in Portales. However, their tenancy must have been short-lived, since they were gone when we arrived. In later years, I had contact with some of that family. Responses I got to my inquiries were not very explanatory. The Carascos evidently moved to Clovis, where they operated a nefarious drinking establishment. One of them was an educator who worked in Portales for a short period of time.

Another account has a Hispanic ranch hand working in the Elida and Kenna areas for a short period. Further accounts have a black man working in the area, also for a short period of time. Except for those instances, Portales, and Roosevelt County for that matter, had a totally Anglo population.

Religion was dominant in the community. Basically, there was a church on every corner—all Protestant, with the exception of a small Catholic mission.

Portales was also dry. I had no knowledge of any of our group imbibing at that point in time—that is not to say that it wasn't happening.

Very few establishments would allow members of our group to patronize their businesses. Barbershops and grocery stores were off limits, except for one that welcomed our business, even to the point of extending weekly credit. That was the Portales Courts and Grocery/Gas Station, owned by

Mr. Johnston. It was located on the curve of Highway 70, where Turbo car wash now stands.

Regardless of whether we were allowed in those places, we only needed to purchase the small amount of groceries we could afford on our meager income. None of the families had vehicles, and if they could have had them, there were no places to go.

Work was long and hard, from early morning until late evening. Weekends were no different than weekdays. As long as it was harvest time, the work went on. I was too young and small to do the work, so I cared for my younger brother. My eldest brother, George—who was a couple of years older than me—was assigned the job of "water boy," carrying gallon jugs of water, wrapped in burlap, for the workers to drink. For this he got fifty cents per day.

Working in the fields in the hot New Mexico Sun was no obstacle. Men, women and children able to work did so without complaint. There were no bathrooms, and if nature called in the middle of the mile-long field, resourcefulness was the answer. Men merely turned their backs; women, on the other hand, were more innovative. Everyone was aware of the situation, and all possible accommodations were made to respect one another's privacy.

When harvest season finished and there was little work, the families prepared to return to the Encino area. A few of the families were offered employment should they choose to remain. Knowing that winter was coming on and the housing would not be suitable, all but two families chose to leave. Our family was one who chose to stay.

The First Families

As memory allows, I will identity some of the families about whom I'm writing. Some were with the original group; others came shortly after. All shared in the adventure.

The Cordova family, who were instrumental in bringing the original group to Portales, had come to the area on a sporadic schedule to work in the fields. It was they who led the farmers to the Encino area to recruit laborers. That family included several members who remain in the area to this day. They were placed at the fairgrounds, too. They were relocated to another farm, not the Kenyon place. It is my belief that they were placed with a Mr. Starr; however, this might not be correct.

Included in the first group were Nick Paiz; his wife, Eumelia; his daughter, Celina (a future educator in Portales); and his son, George.

The Chávez brothers—Mike, Juan and Santiago—also came. They brought their families, including George, Mike Jr., Celia and Senida. Salomon Ortega, his wife and his family—Chris, Orlando, Mercedes, Salomon Jr. and Fred—came to the area as well. Other families, like the Pacheco family—Fidelina, the mother; sons Ben, Robert and Fortunato; and daughters, Elena, Anna and Lydia—came a little later.

Families coming a short time later included Robert Encinias and his family, which included Virginia, Martin, Manuela, Gabriel and Ruben. Even later, the Flores and Romo families came. Others will be presented as memory allows.

My family consisted at that time of my father, Abel Trujillo; my mother, María Soledad Trujillo; my sister, Rita; my brothers George and Abel; and

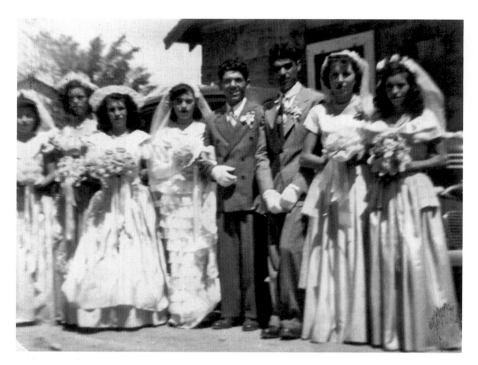

The wedding of Roberto Pacheco and Connie Martínez, two members of first Hispanic families to arrive in Portales. *Author's collection.*

myself (Agapito). My little brother Abel had been stricken with what was at the time called infantile paralysis, later known as polio. He remained paralyzed throughout his life. (More on that later.)

Our given names were quickly changed. Abel became "Abe," Gregorio became "George" and Agapito became "Pete." This was because of the fact that the Anglo farm owners could not, or would not, learn the pronunciation of our Spanish names. I might add here that we referred to ourselves as Spanish, not Mexican, Hispanic, Latino or any other of the modern-day terms. We were simply Spanish American.

As the harvest season began, the work was nonstop. Harvesting peanuts required that laborers work around the clock. First, the peanuts were pulled by hand and stacked in "shocks," piles about four feet tall with the nuts inward to protect them from moisture. After the stalks were dry, two men using long poles lifted the shocks onto a wagon. The wagon then carried the peanuts to the thrasher, which was generally located in the middle of the field. There, workers fed the peanuts into the thrasher while other people sacked and sewed the burlap bags into which the nuts were placed. The

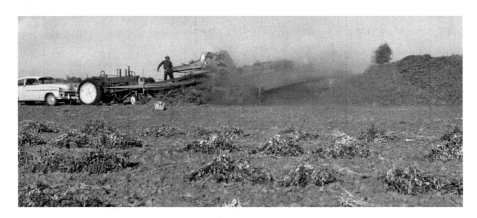

Stationary peanut thrasher. *Courtesy ENMU Special Collections, Golden Library.*

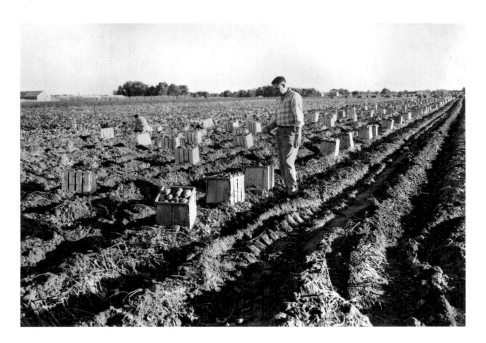

Potato field during harvest. *Courtesy ENMU Special Collections, Golden Library.*

chaff from the plants was stacked in the field and left there for later baling. Oftentimes, only the light from tractors illuminated this work.

After the peanut crop had been harvested, the harvesting of other crops began. Sweet potatoes were grown extensively throughout the county. These were dug up by hand, placed in wooden crates and transported to

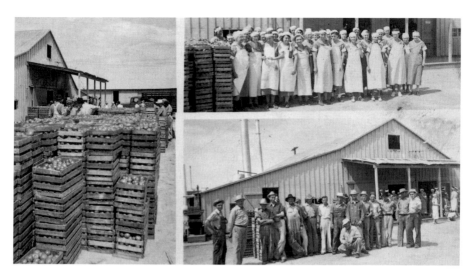

Portales's sweet potato storage warehouse. Sweet potatoes were graded and stored for curing before being sold. *Courtesy ENMU Special Collections, Golden Library.*

curing houses located in town. Other farmers raised crops like green beans and melons. Those were harvested throughout the summer and fall. The Kenyons were mainly peanut and sweet potato farmers.

As I stated before, when the harvest was completed, most families chose to return to the Encino area. Our family, along with Madeleno Jaramillo and his family, chose to stay. Mainly, we had no reason to return to Encino. My father had worked for the Atchison, Topeka and Santa Fe Railroad for a short time and, in a work-related accident, had lost a thumb and was fired without compensation.

The Jaramillo family consisted of Madeleno, his wife, daughter Grace and son Tony. Tony later became a state police officer and was killed during a traffic stop.

As winter set in, the weather became exceedingly cold. By this time, my family had moved out of the granary and into the small house adjacent to the tractor garage. The men now did odds-and-ends jobs. Often there was nothing to do, so there was no income at all. However, those years were war years, and for some reason, the bottom dropped out of the sweet potato market. Because the government needed beef and other meat products, the price of pork skyrocketed. Kenyon bought a large number of hogs. This now became the major work for the winter. Hogs had to be fed—and what did they eat? Sweet potatoes. But because of a government regulation, the

sweet potatoes had to be cooked before feeding them to the hogs. So large barrels were set up over bonfires, and sweet potatoes cooked throughout the night for feeding the hogs the next day. We often swore that the hogs were better fed than we were. Those cooking sweet potatoes sure smelled good.

That winter was very rough. It seemed there was more snow and cold than ever. Oftentimes, there was more snow inside the house than there was outside.

CHAPTER 4

Educational Beginnings

It was at that time that Mr. Kenyon decided that we should be in school. He enrolled Rita, George and me in school. Rita went into junior high, George into second grade and I into first. My teacher was Lilian Marshall. George's teacher was Mrs. Mackinsey, or something similar.

This is where the real adventure and awakening happened for me. By this time, I had learned enough English to get me by. I had not learned to read, and I was far behind all the other students in the class. The first day was quite uneventful, with very little interaction with the other students. The second day, though, is etched thoroughly in my memory. As I entered the room and advanced to my assigned table, one of the little girls jumped up and ran screaming to Miss Marshall. Miss Marshall asked what was the matter, to which the girl replied, "My mom told me that all Mexicans have fleas." Looking back, it is very comical. At the time, I didn't even know what a flea was. I later learned that she meant lice, not fleas.

Miss Marshall was a kind person. The first materials that she had me read were Bible stories from big, colorful books. From those books, and later on from borrowed comic books, I became an ardent reader. She also had a form of punishment that, if used today, would land a teacher in prison. She would call you to her desk and inform you that you had done something wrong and that she was going to "shake" you. She would place one of her hands on your chest and one on your back and start slowly shaking you. By the time she was finished, your head was moving as if it would pop off. A person didn't want too many of those shakings.

Another episode that remains in my memory is an incident where one of the students drew a German swastika on his paper. World War II was going on, and Miss Marshall, being a very patriotic lady, stood that student before the class and made him lick the paper until there was no sign of the swastika left.

We lived a little over a mile away from East Ward, the school we attended. The school bus ran right by the house where we lived, but the bus driver refused to pick us up. He did pick up the kids across the road. So, we walked to school, in all types of weather. Eventually, my father bought a Model A Ford, but on most of the cold mornings, it wouldn't start. So, we walked. Later on, one bus driver called Shorty (I believe his name was Burroughs) did pick us up. He said he didn't care who we were; we were going to ride his bus regardless of what anybody said.

My sister told another story about her educational experience in junior high. In those days, both floors of the old junior high school were in use. There were many times that she would be shoved down the stairs. It is a wonder that she continued going.

After I learned to read, I used books to escape the realities of life. I found that with a good book, I could be anybody I wanted to be and do anything I wanted to do—but more about educational experiences later. The harvest being completed did not mean that the work was over. After school, our mom would take us to the fields where the peanuts had been harvested, and we gathered the peanuts that had been left behind. It was at this time that I began to develop distaste for anything agrarian. I determined that I would someday leave the fields forever.

CHAPTER 5

The First Winter

My dad had purchased an old Model A Ford, and it was our first form of transportation, of a sort. Sometimes it would start; sometimes it wouldn't. Mostly it wouldn't. The radiator had to be drained every night and refilled every morning. On most mornings, the water was frozen, so if we didn't bring water inside the night before, there was no water with which to refill it. In the cold weather, the motor oil became so thick that the motor would not turn over. Oftentimes, my father would build a small bonfire beneath the oil pan to get the oil warm enough to circulate.

World War II was being fought, and many of the men of our group received that dreaded letter to report to their draft board for induction into the armed forces. My mother's only biological brother, Santiago Salazar, had recently lost his life while fighting in Belgium. These men were not averse to serving their country. Their main concern was leaving their families with no means of support. My father received that letter on one snowy winter day. Because he was registered for selective service in the Encino area, he would have to go there for his induction and physical. In order to go there and to provide for his family as well as he could, he sold the car. How much he got, I do not know.

For some reason or other, he did not pass the physical and returned and continued to work throughout the winter. We continued with our schooling, and life went on. On the coldest of days, sunset found us in bed. There, under the covers, we escaped both the cold and the boredom of a darkened house. Our family was very close out of necessity, we had only one another to cling to and on whom to depend.

Christmastime that year came and went with little notice. There were only the two families, and recognition of holidays slipped by with no fanfare. The activities that we were accustomed to were in the past, perhaps never to come around again. The only small remembrance of Christmas in those years was the small classroom party. In a time of war, I am sure our Christmas was similar to that of everybody else's.

Christmas in those days was not as commercial and was more of a religious holiday. Exchanging gifts was not our tradition. The one tradition that my father observed was that of building "luminaries." These he built out of firewood, stacking the logs in a crisscross manner to a height of about twenty-four inches. Generally, there were four of these made. On Christmas Eve, they were lit and allowed to burn completely. They were symbolical guides to lead the three wise men to the Christ child. In recent years, this tradition has exploded, with people constructing multiple luminaries out of paper or plastic sacks and placing electrical lights in them. The name for them has gone from "luminarias" to "farolitos" and back. As Catholics, we would have attended Midnight Mass if we'd had the opportunity.

Springtime brought new adventures. The farming activities now turned to preparing for the new season. Large "hot" beds were constructed out of lumber planks and sweet potatoes were placed in them and covered with a material. I am not sure that plastic sheeting had been developed by then, and I don't know what the material used for cover was. After the beds had been covered for a period of time, they were uncovered; and to a young boy's amazement, the beds were full of sweet potato slips ready for transplanting out in the fields.

As the weather became warmer, the families who had left for the winter began to return, and with them came more people. The fields were prepared for the setting of sweet potato plants. Several women were given the job of pulling slips out of the hot beds and loading them on a wagon to be transported to the setters in the fields. Armed with a stick, the setters put down a slip, pushed it into the ground and kicked the ground on to the slip to anchor it to the ground. They did this over and over, all day long, from early morning to late evening. The backbreaking work was comparable to the shocking of peanuts, but the people worked without complaint. The men, for the most part, wore straw hats; the women wore homemade bonnets to shield their faces from the hot sun.

All this time, I was still charged with taking care of my younger brother. Still, when time warranted it, I would roam the fields where the work was going on. My father was now the irrigation man. His job was to prepare

Adelina Encinias leaving for fieldwork. *Author's collection.*

the rows for irrigation. The water would travel long distances from the well located just west of the Kenyons' house to the fields by means of an earthen ditch. Workers from the government-funded WPA had constructed some of the ditches during the Depression; others were built whenever needed. The WPA ditches were lined with Bermuda grass and presented few problems. The newly built ditches, on the other hand, were subject to ruptures, causing the water to escape. A repairman would walk the ditch and repair any break as well as walk the rows from end to end, cleaning the way for water to run freely. As the field was watered, the ditch was dammed with the use of a canvas or metal water stop. In those days, water was plentiful in the area and the motor-driven well would pump a full ten-inch casing of water and shoot it six feet out.

As the growing season continued, the plants began to sprout. The peanut crop had now been planted and was also beginning to develop. Along with the peanut plants came the weeds. Hoeing the fields became the major work for the summer. Weeds seemed to appear overnight. In those days, there were none of the modern chemicals to keep the fields weed free.

Time passed, and the anniversary of our arrival to the Portales area was nearing. The group of people who had come to tend the fields was growing, and the laborious work continued. But it seemed that as people become accustomed to the work, the more it was accepted as a way of life. The

attitude of the townsfolk had changed very little. The attitude of our group was one of acceptance: we would accept what we had without complaint and make the best of it. Our intent was not to force anyone to accept us or our way of life, even though our way of life was little different than theirs. The only major difference was speech, and that was rapidly changing, especially with the younger group. Although there was very little mingling with people other than with the farm owners, the elders of the group were beginning to be able to communicate with the farmers in broken English.

Spare time, though limited to Sunday and times of bad weather, was spent in physical activity—foot races or high jumping, using a rope or some such object. Strangely enough, although we lived in cramped quarters with many different personalities, I do not remember any domestic disputes or fights. Everybody got along. Husband-and-wife disputes did not happen either, to my knowledge.

CHAPTER 6

Faith of Our Fathers

The majority of the families was of the Catholic faith. As I stated before, there was a Catholic mission in Portales. Priests from Clovis held services there from time to time. Needless to say, church attendance was sporadic. But that does not mean that the families were lax in practicing their religion. My father had been raised in a very religious era. He was a member of the brotherhood known as Penitentes. Contrary to popular belief, the brotherhood strictly observed religious holidays and adhered to strict Catholic doctrine. As a small child, I had the opportunity to witness a Lenten procession and to visit the *morada* in which they worshiped. On coming to Portales, his ties to the brotherhood diminished due to the lack of a congregation. His Catholic beliefs remained with him throughout his lifetime. Many were the times I suffered through a rosary prayer service on my knees because my mother insisted that we keep the faith.

At some later time, Pedro Larranaga and his family joined our group. They were Jehovah's Witnesses. It was a good while longer before our group included members of the Protestant faith. Stories about them will be included in the time frame that they joined the group.

Fieldwork

Time passed, and in my young mind, the days, months and years were not measures of time. Life was just the advancement from one adventure to the next. My parents either sensed that I was not physically or mentally geared for agrarian work, or perhaps I was too hardheaded to be taught. The first time I was attached to a hoe, I almost lost a toe. That resulted in a trip to town, where I was outfitted in my first pair of engineer's boots. On return to the field and hoe, I promptly planted a deep gash in the toe of one of my new boots. Needless to say, my first experiences with a hoe were not very promising. During peanut harvest, though I worked as hard as I could, the peanuts always won. The faster I went, the more behind I got. Digging sweet potatoes and tapping onions garnered the same results. Setting out onions or sweet potatoes was not compatible with my attitude. So for the most part, my time was spent tending to my little brother or out exploring the general area. The cemetery was near where we lived, and I loved to go there and wander around looking at the many different tombstones.

We had lived on the Kenyon farm for three years or so. During this time, there had been very little change in the townspeople. Some of the storeowners had become more lenient in their attitude toward us. We had discovered that we could attend the movie theater without incident. That in itself was an adventure. Having never been in a theater; my first time felt as if I were stepping into a wonderland.

I can't remember what movie I saw, but I'm sure it was a western. The name on the theater was YAM. Next door was a little shop called Candy

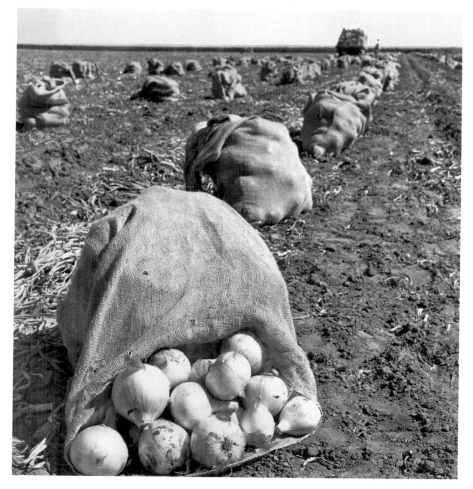

Onions during harvest. *Courtesy ENMU Special Collections, Golden Library.*

Kitchen. The aroma coming from it was out of this world. The theater had lights on the ceiling, but I thought they were stars. I was totally fascinated. The movie theater became the major escape from the daily routine of hard, hot labor. This luxury was, by necessity, reserved for the weekend. The theater offered not only the entertainment of the movie but also an escape from the hot summer sun. Oftentimes, a person would sit through two showings of the same movie. An added luxury was that, on occasion, the theater would run a double feature.

The movie theater management welcomed everybody and accepted our patronage without question. On one occasion, there was a drawing for

Irish potato farmer (possibly Mr. Hatch) displaying produce. *Courtesy ENMU Special Collections, Golden Library.*

a brand-new pickup truck. One of our group was the winner. José Baca became the proud owner of a new truck. If I remember correctly, it was bright yellow.

Although the theater offered respite from the heat, it seemed that most of the people were accustomed to the hot sun, and the only air conditioning that we had was an open window. Refrigerators, if they existed, were something that we didn't have until much later. Again, an open window served as ventilation. If there was something that had to be kept cool, it was placed in an open window, and the breeze would keep it somewhat edible. Obviously, not many perishable items could be kept. Ice was not something that was available to us either. This was not a problem because these conditions also existed before we arrived in the area. Refrigerators and air conditioning had not been readily available to us before.

Moving On

There came a time when, for whatever reason, it was time to move on. Our family was going to move to another farm and another boss. Evidently, agreements had been made among the farm owners that different families would go to different farms to live and work. Nick Paiz's family and later on, the Pacheco family, would remain on the Kenyon farm.

The farmer whom we were going to was a man named, according to my father, "Benson." My father's pronunciation of the name was not quite exact; the actual name was Vinzant. W.G. Vinzant was the county agent and was a "gentleman" farmer. He was the only farmer who wore a suit and tie while working on the farm. Vinzant and his brother-in-law Elliott Jewett operated the farm. In essence, my father would be working for both of them.

Vinzant had a son and a daughter. I met the son, Bill, on several occasions, but the daughter I did not. Jewett had a daughter whom I met on occasion, too. All were very good people and also treated us with dignity. The time that we remained with these farmers is a blur in my mind, and the narrative of that tenure will be short. We moved to a place that had two houses. One was a beautiful house and was fully furnished. It seemed like the people who had lived there had just locked the doors and left. Beautiful furniture could be seen through the windows, and the house itself was in good repair.

The second house was a two-story building; the bottom floor was a one-car garage with a dirt floor and no door. The second story was a two-room setup. This was to be our home. One room was a kitchen and the other was

the sleeping quarters. The kitchen had only enough room for a three-burner kerosene stove and a washstand with a dishpan for dishwashing. There was no running water and no electricity. It was basically the same setup we'd had on the Kenyon farm.

However, here we had something else: snakes. In all the time that we lived there, there was not a single day that went by that we didn't see several snakes—rattlesnakes, bull snakes, black racer snakes, all types of snakes. I, still not being a fieldworker, was around the house all day. I developed a phobia so bad that to this day, I have a dreaded fear of anything resembling a serpent.

The farm work went on that summer. My father worked for Vinzant or Jewett on a daily basis, and the rest of the family worked for other farmers, hoeing or doing whatever needed to be done. There was another family sharing the living quarters. I believe that they were cousins of mine. Luckily for me, our tenure on that farm was not long. Late that fall, we packed our meager belongings into a small pickup and left. My anguish and fear of that place was so terrible that I must have developed a mental block. To this day, I have never been able to locate the farm or the house that we lived in. I have looked for it and asked about it, but it is as if it has disappeared off the face of the earth. To this day, I search for it every opportunity I get.

Return to the Homeland

Idid not know why we left Portales. I only remember that we left Portales in the early morning and arrived in Vaughn, New Mexico, late that night. For some reason, it always took all day to make that drive of 150 miles. When we arrived in Vaughn, we had no place to stay. A relative took us in, and we were given one bedroom and kitchen privileges. I figured that something bad had happened, and we had to leave Portales.

Vaughn, in my opinion, was the worst place in the world. It was cold, windy and horrible. I thought this would be the place where I would live from now on. It was late fall, and we were enrolled in the school there. I disliked the school as much as I disliked Vaughn. I didn't like the kids; the kids didn't like me. I didn't like the teacher; the teacher didn't like me. I was ready to get back to Portales.

A few months later, my baby brother José Armando Trujillo was born. At last, I knew why we had left Portales. After the birth of José Armando, later to be renamed "Joe," we remained in Vaughn for about a month. Unknown to me, my father had been making arrangements for us to return to Portales. He had been in contact with one of the farmers, and a house had been secured for us to move into.

Once again, our meager belongings were loaded into the back of a small pickup, and we headed back. We left Vaughn early in the morning, around four o'clock, and drove all day, arriving in Portales after sunset. I later realized that the reason it took so long was because of the wartime tires and tubes. Instead of rubber, the tires and tubes were made of a composite

material, and traveling took its toll on them. Flats and blowouts were a common occurrence. In those instances, the wheel had to be removed and repairs made on the spot.

CHAPTER 10

Portales Again

W e arrived in Portales and located the house that was to be our home. We learned that the farm owner was Orville Doak. His farm was about a mile east of the Kenyon farm. He planted peanuts and sweet potatoes and also provided custom alfalfa hay baling for other farms. (Actually, the only custom there was to it was that he owned the only baling machine in the area.) The house that we moved into was a small two-room house. There was no inside plumbing, but there was electricity. This was an improvement.

My father's primary job was irrigation. During growing season, this was an around-the-clock job. Night after night, we were lulled to sleep by the sound of the motorized irrigation wells. The rest of the family, aside from myself, worked at hoeing or other fieldwork. Living on the Doak farm became an adventure in itself. Doak had a son, Rodney (called Rod), and a daughter, Donna Beth. Donna Beth was older than me and suffered from asthma, so she was very seldom out and around. Rod, on the other hand, was my age and rambunctious, ready and willing to get into anything and everything. He and I became running partners and constantly stayed in trouble.

As work continued, my dad learned how to drive a tractor and began doing the plowing from time to time. There were two other families living and working on the farm. Mr. and Mrs. Warren were an elderly couple; Mr. Warren was the full-time tractor man. The Warrens were very likeable people and became very instrumental in helping me learn to read and speak English more fluently. They had a flock of chickens, and we would often buy eggs from them. They would invite George and me into their home. Mr.

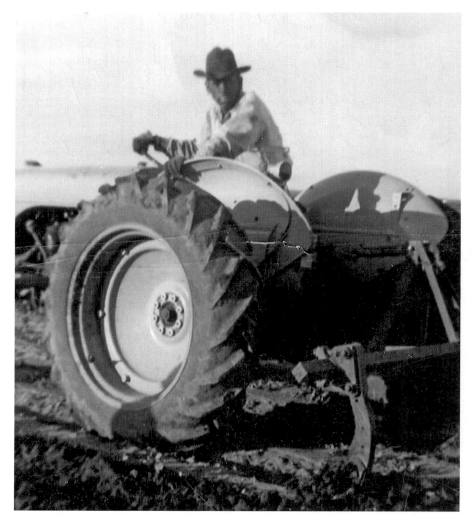

Abel Trujillo preparing a field for planting. *Author's collection.*

Warren had a radio, and he would listen to it every night. We would sit with him and listen to the radio late into the night—nine o'clock was considered very late. We listened to *Fibber McGee and Molly, Amos and Andy, Red Skelton* and all the other radio shows of the day. Along with the radio, they also subscribed to the Portales newspaper. Mrs. Warren would keep every copy and read to us things that she found interesting. She also introduced me to the comic strips. She would give me the old copies of the newspaper, and I would read the comic strips over and over. My favorites were *Alley Oop, Mutt*

and Jeff and many other long-gone strips. All of this made me hunger for even more reading material.

The second family, named Bryant, lived in a larger house about a quarter of a mile away. That family consisted of Mr. and Mrs. Bryant and their son, Denzil. Denzil was a few years older than Rod and me, but he was kind of a mom's boy. His main goal in life seemed to be the first to tattle to his mother on whatever Rod and I were getting into. His father was a tall man and appeared to be the meanest man in the world, not because he ever harmed me or anybody else but because of the way he spoke. Mrs. Bryant, on the other hand, was a very gentle woman. She had a garden and raised vegetables, some of which she used fresh and others she canned. I once saw Denzil cutting the tops of some of the vegetables, and I ran to tell her that instead of digging up the vegetables, Denzil was snipping off the tops. I thought he had lost it. Well, it turned out that the vegetables were turnips, and she was going to cook the tops. That was our introduction to turnip greens.

As I mentioned before, Doak had a baling machine. This was a tractor-pulled machine with which newly mowed alfalfa hay and peanut hay were made into bales. A crew—consisting of a tractor driver; a hay feeder; and someone to tie the wire, called a wire punch—operated the machine. The crew was made up of George, who was about nine years old, as the tractor driver; my father as the feeder; my sister Rita as the puncher; and another woman by the name of Julia Montoya, also as puncher and wire fastener.

George learned how to drive the tractor, and he became the driver pulling the machine. If he were alive today, he would tell you that he drove that tractor asleep most of the time. The feeder's job was to push the hay that was lifted up by a conveyor into the chute of the machine. There was a mechanism that forced the hay into a square space that measured about two feet by two feet. The hay was forced in for about four feet and then a wooden block with slots was dropped in to separate the bales. The puncher punched a wire with a looped end through the slots in the block, one at the beginning of the bale and one at the end of the bale, top and bottom. The tie person intercepted the wire on the other side and tied them together, thus forming a bale. This work would go from the time that the hay was dry from the morning dew until late at night. Oftentimes, the crew worked throughout the night.

One time when George was ill, I was appointed tractor driver. George was able to drive the tractor at just the correct speed, not too fast or too slow. I was taught how and when to shift, and the workday began. I was constantly yelled at to slow down or speed up. I was never going the correct speed, but

I was driving. We approached the end of the field where I was supposed to turn, and I spun the tractor wheel rapidly. Much to my chagrin, the wooden tongue that attached the bailing machine to the tractor snapped right in two. That was the end of my tractor-driving experience. More and more, I was convinced that life on a farm was not for me.

As the baling crew continued, they went from farm to farm. Sometimes, I went along as a block retriever, running behind the machine picking up the wooden blocks and carrying them to the feeder. The blocks were heavy, and the newly cut alfalfa was sharp as a razor and cut just as badly. I got the crazy idea that if I nailed a strap to the blocks, they would be easier to pick up. I did, and that made the job much easier. I had it made, or so I thought. Doak saw the blocks, and he got the even crazier idea that if he replaced the strap with a piece of rubber cut from an old tire, the wire puncher could grab the block as it came out of the bailer. That eliminated my job, but I didn't mind.

During this period, my mother didn't work in the fields, which gave me more time to wander around and get into things that I shouldn't have. Mr. Zahn owned the farm adjacent to the Doak farm. He was also a peanut farmer. The Zahns were of German descent and were very nice people. However, Mr. Zahn had a very mean-looking appearance, and I was really afraid of him. Mr. Zahn had two sons, Richard and Melvin. Richard was older than me and also had a very mean-looking appearance, so I didn't have much interaction with him. Melvin on the other hand, wanted to be mean but didn't know how. According to his own admission, he was the black sheep of the family. Melvin spent most of his time looking for ways to get out of work. He was pretty good at it. He claimed that he was German and a close kin to Hitler (a bad position to hold during those times). His story alternated to suit his fancy. He was basically a good kid, a few years older than I. I learned some choice curse words from him. After we left the Doak farm, I didn't see him very often and lost track of him until years later, when he came through town with a group of hippies. He had aged and looked pretty rough. After that, I never saw him again.

CHAPTER 11

The Final Trip to the Birthplace

After the harvest was over that year and Christmas rolled around, my parents decided that we should spend the holidays with my father's family. They still lived on the original rancho near Palma Route, which was in the area between Santa Rosa and Clines Corner, just off Route 66 on State Road 3 going toward Villanueva, New Mexico. My father had purchased an old pickup, another Model A Ford. He had fashioned a camper of sorts, which was really just a wood frame with canvas stretched over and nailed to it. The whole family, which now included baby Joe, loaded into the vehicle, along with several blankets and a tarp to throw over all of us who would be riding in the pickup bed. The pickup had no heater, so blankets were the source of heat for the passengers in the cab as well. The trip took from very early morning until late at night. We arrived and enjoyed the holidays with family, the first we had spent with family in several years. After the holidays, around January 2, we loaded up for the return trip to Portales.

As we left, we went to Clines Corner and took the road to Encino. We drove up a slope called Holman's Hill, named after an old lady who operated a service station in the area. It had snowed the night before, and the road was icy and slick. As we progressed up the hill, the pickup began sliding. Just before we topped the hill, the pickup left the roadway. Slipping on the icy road, the pickup began to tip over. It went over on its side and then began to roll down the hill. It rolled several times, leaving our belongings strewn behind it. The pickup finally came to a stop about fifty yards from the highway. Those of us who were riding in the bed of the pickup had

been ejected on the way down. The occupants in the cab rode the rolling vehicle all the way to the bottom of the hill. My father was pinned under the cab, and there was gasoline dripping on him. My sister Rita ran to the overturned pickup and physically lifted it so that my father could crawl out from under it.

As we composed ourselves as well as we could, we noticed that baby Joe was missing. As we looked around, we found him safely lying on a snowdrift some fifteen yards away from the wreckage. To this day, we have not figured out how he got there. The only thing that we could figure is that there was a soldier in uniform that jumped out of his car and ran to help. He might have found the baby and took him to the snowdrift. But there were no footprints leading to the drift, and the soldier disappeared as fast as he had appeared. Regardless, Joe was safe and sound, without even a slight scratch. Besides my father's bruised chest, the only other injury was George's broken front tooth.

The pickup sustained major damage, and it took a considerable amount of time to be repaired. After it was deemed somewhat roadworthy, we returned to Portales. Doak had been kind enough to hold the work for us and also had sent my father funds to help get us back. After that one trip, we never returned to the place of my birth, and except for an occasional funeral of a relative, we never returned to that area of New Mexico. We were resigned to the idea that Portales would be our permanent home.

CHAPTER 12

Portales to Stay

We had been attending school since we first enrolled while living on the Kenyon farm. When we moved to the Doak farm, the principal of East Ward School promptly told my parents that we were no longer in that particular school's district and would have to transfer to Central Grade School. The school bus would pick us up, but we would have to walk half a mile to catch it. If we were not at the bus stop when the bus came by, it would not wait. Some mornings we were within half a block when the bus came by, and we ran to get there. Even though the driver saw us, the bus would leave. Other kids on the bus thought it was funny.

My third grade teacher, Deborah Smith, was a kind, elderly lady. She treated me just as she treated everyone else. I had, by this time, learned the English language and could read and write as well as the other students. My only weakness was arithmetic. Mrs. Smith paired me with another student, Doris Greer.

Under her tutelage, I learned how to add, subtract, multiply and divide. I enjoyed the attention that Doris gave me so much that I pretended not to be able to do the work. My third grade year was very enjoyable.

During this time, another family joined us in Portales: the Noberto (Robert) Encinias family. I have mentioned their names previously. I don't remember what grades Virginia or Manuela were in or where they were attending school. Virginia is about the same age as me, so she was probably at the same grade level, with Manuela a grade or two behind. Their brother, Martin, was just starting school. By this time, I was a fluent English speaker. Martin, on the other hand, knew no English at all.

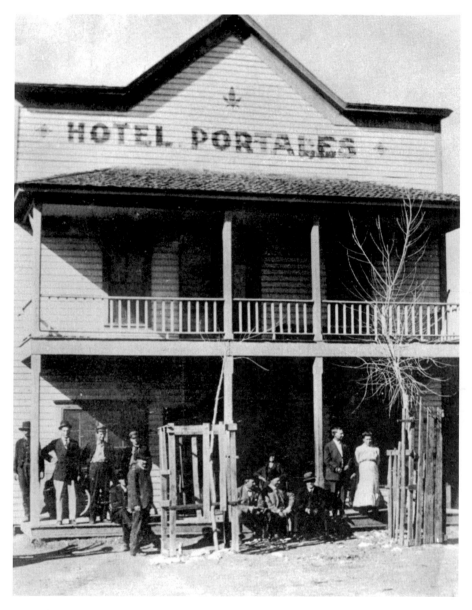

An early Portales Hotel. *Courtesy ENMU Special Collections, Golden Library.*

In those days, there was no school cafeteria. There were small, privately owned stores adjacent to the school playground where students could purchase snacks and sandwiches and, at this particular store, soup. Martin, not yet able to communicate in English, could not tell the server what he

wanted, so I told him to just say "soup"; thus, he had warm food daily. This went well for about a week. One day, he approached the server, and the server asked what he wanted. Martin answered, "no soup!" Martin was a fast learner. So now we were not the only non-English speakers in the system. For a short time, there was a boy, Richard Montoya, and his cousin, Elena (or Helen, as she was called), attending school also. But they left and went back to Morarity, New Mexico.

Mrs. Encinias was my father's sister, so the newcomers were family. They obtained employment with Elliott Jewett, the same farmer who had employed my family. Their first house was located on the second curve of the Arch Highway. It was a neat little house, far from everything and everybody. They lived there until Orville Doak hired Mr. Encinias as the irrigation man to take my dad's place when he took over the baling machine crew.

Doak, like W.G. Vinzant, I always thought of as a "gentlemen" farmer. Doak was a teacher at the local junior high school. I'm not completely sure, but I believe that his wife was a teacher as well. At any rate, he came out to the farm after school and on weekends. Sometimes, he would bring other school personnel with him. I once met L.L. Brown, after whom the early childhood center is named. I also came to know R.M. James, whose name one of the elementary schools now bears.

Other people were beginning to return on a regular basis, but most left after the harvest. Meanwhile, we continued to be the only Spanish-speaking students at school. It was during this time that we began making the transition from Spanish speaking to English speaking. A person is not totally fluent in a language until he or she begins thinking in that language. Many times, I found myself trying to understand the transition of thought from one language to another. For example, in the Spanish language, everything has gender. That is not the case in the English language. I believe that at that point in time, I was becoming a totally English speaker. This is further evidenced by the fact that I began forgetting a lot of my Spanish vocabulary. My brother George was doing the same. He and I communicated totally in English. Carrying on a conversation with our parents, who were still totally Spanish speaking, became awkward. We started to converse with them in what became known as "Spanglish."

As time went on, it became more pronounced that we were losing the ability to converse with people of our own nationality. It wasn't until many years later that I would begin making an effort to regain my native language, both written and oral. The incidence of this happening was not entirely our fault. We were not allowed to speak Spanish at school, and if we had,

Sandra and José in front of their house on the Doak farm. *Author's collection.*

nobody would have understood us. If we spoke Spanish among ourselves, we were laughed at. Several teachers, including Doak, would punish us if they heard us speaking Spanish. So, we spoke English.

About that time, the Encinias family moved to the Doak farm, and the Bryant family moved to town. We were given the option of moving into the house that

they vacated. The house was larger but not any better than what we lived in. But because it was larger, we moved. Sometime later, another uncle and his family came to work during the summer. Uncle Juan Aguilar; Aunt Ramona (my mother's sister); their son, Pablo; and their daughter, Mary, moved in. We shared the house. Uncle Juan was the kindest, most patient person that I have ever known. Pablo was younger than me, as was Mary.

Also that summer, they brought another cousin to stay with them. Lugarda Jaramillo was my age and the most gullible person ever. Doak had electric fences around some fields. Well, it became our responsibility to see how many times we could get her to touch the wire. The first time was easy. After the first time, we had to devise different ways of fooling her into touching, spitting or throwing water onto the wire. It is a wonder we didn't electrocute her. This went on until my father found us out. Needless to say, we ceased that with some friendly persuasion from Dad.

Before the Bryants left, Mrs. Bryant taught my mom how to prepare okra and turnip greens. These two vegetables were new to us. We knew about turnips, but we were not aware that the greens were edible. Okra, she learned to prepare in different ways—fried, boiled, pickled. We learned to really like that.

One thing that we really missed was hot green peppers and red chilies. The only peppers that could be found were bell peppers. The hot variety was unheard of. My father had some seeds from northern New Mexico sent to him, and he planted a small garden. He raised some really good chilies and many tomatoes. We had tomatoes prepared in every way imaginable. Just before frost, we picked the vines clean and stored the green tomatoes under straw in a shed. Thus, we had tomatoes until late in the winter. Mom also canned tomatoes and made tomato juice. The chilies we ate green during the growing season, and then we ate dried green (freezers were unheard of) and red chilies throughout the winter. My father also planted watermelons. Pablo and I couldn't wait until they ripened, which resulted in more disciplinary action.

After the harvest, the Aguilar family left. We really missed them, but the Encinias family was there to stay. So, the long winter was not as lonely as winters past. During Christmas, they stayed overnight with us, which made for a very enjoyable occasion.

We continued to attend school. I was now in fourth grade. My teacher was Christina Chalk. She was a wonderful teacher, very sensitive to my educational needs. She sensed my desire to learn, and she provided materials that stimulated my interests. All was going well, and I was content. Most of the students in the same room were easy to get along with. Problems arose

when I was away from the classroom and around students who didn't know me. However, I became a fast talker and could generally talk myself out of most scrapes.

Back on the farm, things were going as usual. Doak decided that he wanted to move his family out to the farm. He decided to build a new house in the exact location that the house we were living in was. So, we were told to prepare everything in the house for moving. Early one morning, a moving crew showed up and loaded the house onto a trailer. By noon the same day, the house was relocated to the edge of a field around a mile away. The house we lived in was now located near an irrigation well that would be our source of water.

We would ride the same bus, but now instead of walking down a road to catch it, we would walk across a large field. It seems that the winter was especially cold that year, and the walk was very uncomfortable. It was a blessing to get to a warm classroom. We lived at that location for a couple years. The Encinias family moved from the Jewett farm to the Doak farm. Because there was no other house, they moved in with us. This was a good arrangement, as we all got along really well. Fieldwork was still something that I detested. I did go out into the fields and did some fieldwork. But I did not like it, and I was not very successful at it.

That summer was an unusually enjoyable one because, with the Encinias family living with us, I had somebody to play with. Martin, Virginia and Manuela were close to my age, and we got along well. That summer, I learned how to play games I had never known. Before the summer was over, another house became available for the Encinias family, and they moved out. They were still located on the Doak farm but were several fields away. We remained where we were through the winter. In the spring, Doak decided to move the house again. It was loaded up on a moving company truck and moved back to around one hundred yards from where it was originally.

To my young mind, it seemed that we really had it made. We had bought a record player and several records. There was also a radio that we could listen to. To beat the heat, we had a small fan. The fan's only function was to circulate the hot summer air, but it seemed to help. Also about this time, we bought a used car, a 1939 Willis Aero, black with cloth upholstery and an actual heater. Compared to the makeshift pickups we'd had before, I thought we were really in tall cotton. Many years later, I learned to drive using that car. We kept that car for many years; on occasion, when I was in high school, I would drive it.

A family, also from the Encino area, moved in about a half mile away from us. The Pedro Larranaga family consisted of Mr. and Mrs. Larranaga; their two daughters, Versavela and Josefita; and a son whose name I do not recall. They lived and worked on the McCollum farm and became longtime residents of Portales. Also about this time, there was an addition to our family. I suppose I was too young and naïve to realize that this addition was coming. One day when I came home from school, I was surprised to learn that I had a new baby sister. Sandra Sue was the first Trujillo born in Portales. I suppose that Dr. E.T. Hensley had made the house call to deliver her. He became our family physician until he passed away many years later.

Another pair of cousins, Elizardo and Flora Encinias, came to stay with us for harvest season. While they were there, Bascilio (Ben) Pacheco began coming around quite often. After Flora left, he quit coming around. He later married Josefita Larranaga. Bascilio drove a Model A Ford, and we could hear him coming around long before we saw him.

This living arrangement went on for several years. During all of this time, the house had received very little repair and only what little upkeep my family could do on their limited income.

The Hispanic population was beginning to grow. Several other families, either some of the original ones returning to become permanent residents or new families, were coming in. Most of them were from the same general area of New Mexico as the rest of us. Among these were the Villanueva and Montoya families. These two families were closely related and came from the village of Villanueva, which is located south of Las Vegas, New Mexico, nestled along the Pecos River.

CHAPTER 13

Becoming Homeowners in an Adopted Land

A s time went on, my parents began talking about trying to purchase a house in town. They began looking and found several that the owners were willing to sell to us. All were located on the northwest side of town. My father looked and tried to find an affordable place. Some of the people to whom he talked advised him not to buy in that area. In those days, the drainage system in Portales was geared toward draining into that area. If it ever rained, there would be a lake created there. I have hesitated to include Spanish dialogue in this narrative, but for descriptive purposes, that area was called *la laguna,* which in English is "the lagoon." With that information, we stayed clear of that area. In later years, my sister Rita did live in that area for a short period of time—until it rained. We had to move her out using a raft. Water was waist deep inside her house.

We looked at a small five-acre plot just north of town, but when the owner learned who we were, the price doubled. My parents finally located a place in east Portales. The building—I hesitate to call it a house—was about twelve feet by twenty feet, with a semi-flat roof. The inside wall height was just over six feet. The lot was fifty feet wide by one hundred feet long. Interestingly, this was an old granary sold as a house. There was no plumbing or electricity. In order to buy it, my family had to borrow funds from my grandparents for the earnest money. This was money put up as intent to purchase, nonrefundable if we were unable to come up with the full purchase price within a certain period of time. Going to a bank for a loan was out of the question. Bankers would openly laugh at

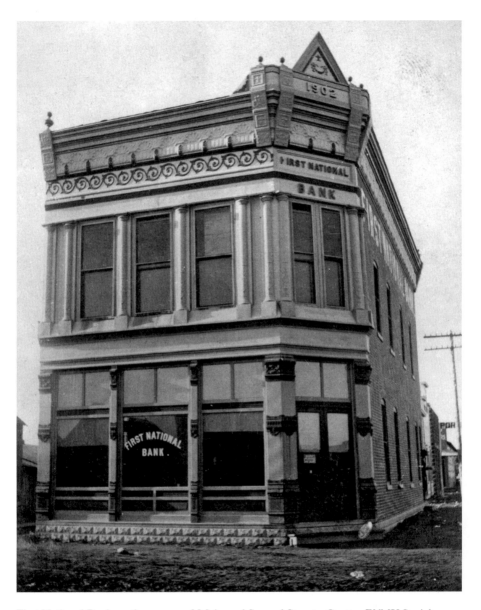

First National Bank on the corner of Main and Second Streets. *Courtesy ENMU Special Collections, Golden Library.*

us. In order to obtain the needed funds in the required time period, my dad went to a high-interest loan company.

At my age, finances were not important. I did not know what the cost of the property was. I do know that it seemed like my parents were making

payments forever. The building needed a lot of work before it could be used as living quarters. First, water and electrical services had to be acquired, which was no easy chore. There was no sewer system extended to that area of town. An outhouse had to be built and a deep hole dug through the hard caliche dirt. This we located at the rear of the lot, adjacent to what could be considered an alley. Again this was problematic because the city was averse to allowing an outhouse, yet septic tanks were not allowed. Eventually, this was completed, we had a brand-new two-seater outhouse and work on the house began. My chore was to clean the lot of weeds and junk. The two rooms were divided. One of the rooms was made extra small; the space acquired from that room became the kitchen. The kitchen consisted of a metal sink stand, a kerosene cookstove and makeshift wood cabinets.

The middle room, the smaller of the two, became a bedroom for my little brother Abe, who was bedridden. The larger room became a combination living room–bedroom. My parents planned to add on as time and finances would allow. Though not much better than what we had lived in since arriving in Portales, this was ours. We continued to live on the Doak farm, working on the house whenever we could.

My dad, Rita and George were still the hay baling crew. The baling crew worked on several farms. Perhaps the most memorable farm was the one owned by E. T. Hensley Jr. He was a district judge and had a farm at the edge of town. What made that particular farm memorable were the peach trees that surrounded it. Those trees produced the most delicious peaches ever. Whenever there was work to be done on the Hensley farm, we were sure to taste the fruit, green or ripe.

A comical incident that George and Rita recalled and laughed about many years later involved Judge Hensley's sons—Fred, Bill and Jack. Jack was the youngest of the three and was not part of the episode. But Fred and Bill decided that they needed to guard their peaches against the baling crew. They took turns guarding around the house. Little did they know that the better fruit was a half mile away and out of their sight.

All three boys were our good friends as we grew up. Sometime during that time, George became very ill. E. T. Hensley Sr. was a physician and he diagnosed George with a ruptured appendix. Dr. Hensley performed emergency surgery, and George recovered. Whatever fee Dr. Hensley charged, he allowed us to pay out or exchange for work.

While living on the Doak farm, some very memorable things took place that had a great impact on our future in Portales. We were isolated in a populated area. Friends to visit with were few and far between. Trips into

town were just as rare. Once, a cookware salesman made his way to our doorstep. He put on a cooking demonstration that was really impressive—so impressive that my parents decided to purchase a set of the aluminum pots and pans. The price was more than we earned in several months, but we badly needed the utensils. If a salesman could bake a cake on a kerosene stove, mom could create wonderful meals. So a sale was completed, and the cookware was paid for, in cash. The salesman said the cookware would be delivered in two weeks or so. Meanwhile, he was going to leave the one pot he had cooked in as a bonus. He wrote out a receipt for the cash and left. We never saw him or the cookware again. The receipt had a false name and address and no phone number. We had been taken. But from that experience came knowledge. It would never happen again.

Another time, a Watkins salesman came around. His wares were in his car and deliverable upon purchase. For twenty-five cents, my mother purchased a jar of lemon pie filling. Using the high-priced "bonus" pan and the lemon pie filling, she prepared the most delicious pies that were ever made.

Most importantly, a Baptist missionary, A.D. Reed, found his way to our house. He visited with my parents for some time. As I stated earlier, we were of the Catholic faith. But again, we were unaware of when or where we could attend church services. Mr. Reed and my parents agreed that he would come to our house and conduct services. This was the beginning of a long friendship with the Reed family. Although our family was never converted to the Baptist faith, Mr. Reed conducted services in our home for several years. My father located and purchased an old pump organ that Mrs. Reed would play while the small congregation sang. This was the origin of the Spanish Baptist Mission in Portales (later renamed the Spanish Baptist Church). Prior to that, the church community maintained the same attitude toward us that everybody else had.

Mr. Reed was instrumental in George and me becoming Boy Scouts in a troop sponsored by the Calvary Baptist Church. Mr. Reed was the Scoutmaster. George and I would walk to town every Monday night to attend meetings. We continued this for several years and both attained the rank of Life Scout and were working toward the status of Eagle Scout. For some reason, Mr. Reed had to leave his position as Scoutmaster, and another man took his place. All of a sudden, things changed. George and I could do nothing right. The new Scoutmaster's ire was always upon us. George dropped out, and not long after, I did, too. It was difficult for me to understand why this man, a respected church member and director of a local children's home, could dislike us so much.

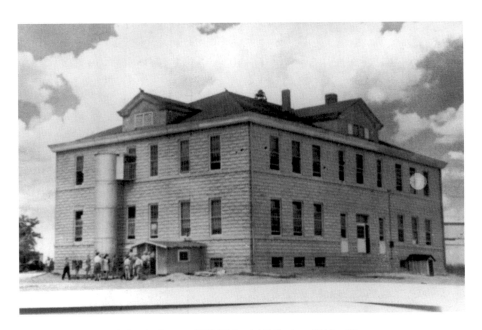

Old Central Grade School. *Courtesy ENMU Special Collections, Golden Library.*

School was going pretty well. I was learning and enjoyed the time in class. In all the years that I was in school, I can honestly say that I never skipped or cut class of my own fault. I thought school was exciting, and I was afraid that I might miss something. Every teacher that I had up to that time had been very motivating and caring. I wish I could say the same for the administrators. I was promptly informed that because I would be moving into town, I would have to change schools because I would be living in a different district. In those days, attending a school out of your district was prohibited, or so we were told. I had grown to like Central Grade School and had made friends with several of the students. Now I had to leave and begin the whole process again. Later on in this narrative, I will go deeper into to the educational concept of districts and their eventual displacement in the Portales municipal schools.

After our move to town, I was assigned once again to the East Ward School, where I had begun my educational experience. I was now in fourth grade, and I was assigned to a male teacher, Mr. Chambers. His classroom was located in an old barracks building that had been moved on to the school grounds. The remainder of that year was uneventful. But my grades began to decline.

For the fifth grade, my assigned teacher was Miss Doris Hopkins. She was a very good teacher, and I excelled in math and most other subjects. Conflicts

with other student, however, made for an unpleasant year, with many trips to the principal's office for discipline, much of which I felt was underserved. Somehow, I survived that year and was advanced to sixth grade. That school year is a total blank in my memory. I cannot remember the teacher. I am sure that the students were the same, and I remember competing with other students for a spot on the sixth grade basketball team. I thought I was a more effective player than most of the other students, but I was eliminated and had to settle for bench warmer. That May, I was advanced to seventh grade and entered junior high school.

Quite a few of the original families that accompanied us from Encino had now moved back in pursuit of work. Salomon Ortega's family—along with the Garcia family, which included Julia, Roberto, Gus, Arcelia and Elmer—had now moved into residences in north Portales. The Chávez brothers were there as well. The Flores family had migrated from Corona, New Mexico, which is a few miles south of Encino. The Gallegos, Montano and Romero families also relocated to the area. Other families were moving in at a steady pace. Some of the names mentioned later played an important role in the history of the area. At this point in the story, however, most of these people were involved in the agricultural labor force.

This group of families actually became a close-knit group. For recreation, on several occasions, a fiddle, borrowed from Bruce Gray (a local violinmaker), and a guitar made for a good dance, as long as musicians could be found. These dances were held in the tractor shed on the Kenyon farm. Dancing went from evening to dawn. To my knowledge, there was only one disagreement, and that was settled quite promptly. In later days, those dances were held at different locations.

At those gatherings, I became aware of an individual providing homebrew, a type of homemade beer. (Portales and Roosevelt County were still "dry.") About this time, I met the Flores boys for the first time—Chris, Tuna (his nickname) and Joe. They had a sister, Corrine, and later another sister named Jayne. These people will also later impact the history of the area.

Joe Flores and his family established a Mexican restaurant in north Portales. The restaurant was housed in a building that had been a chicken hatchery. The restaurant became a huge success and was in existence for many years. Later under different ownership, the restaurant relocated. The success it had experienced at its original location did not develop in its new location.

As I mentioned earlier, the Portales schools were divided into districts. Each district was assigned a particular school. Lindsey Elementary was

Moonshine still captured by law enforcement in "dry" Roosevelt County. *Courtesy ENMU Special Collections, Golden Library.*

located in north Portales, so most of the families moving in were assigned to that school. In later years, the population in north Portales was almost totally Hispanic. The student population at Lindsey was also totally Hispanic, except for one student. A later chapter will discuss this in depth.

Most of these arrivals began buying residential properties in the area earlier described as the lagoon area. That area presented the most available land, but the property owners were reluctant to sell to Hispanics. Still, that area became populated by the new arrivals. The Ortega family established their residence there, as well as the Chávez brothers.

There was one particular resident there that, in my mind, was a very interesting person. Frank Rogers (who was not from the Encino area and not with the original group)—along with his wife and two sons, Johnny and Kiko—set up his family's living quarters in a tent. They lived in that tent for as long as I knew them. They were hardworking people, originally from Mexico. The original dwelling that they purchased—at an inflated price—would have been deemed uninhabitable by today's standards. With hard work and an ability to adapt, the new residents made the place livable and improved its appearance. In time, the city developed a drainage system so that the occasional rains did not create the flooding

that they once did. The Ortega family and others built beautiful homes in an area that was at one time considered undesirable.

The place that we relocated to was on a street then known as East Oak Street. Our house was designated as 808 East Oak Street. Later, the city went through a systematic renaming of all streets, and ours was renamed East Brazos Street, with our designated house number as 824.

On the Doak farm, there was an unused shed, about twelve feet by twelve feet. We bought it, loaded it on skids and pulled it into town, where we set it up at the rear of the original building. This became a bedroom for George and myself. Later, when the city extended the sewerage system and the outhouse had to be replaced, this shed was converted into a bathroom with a commode and a lavatory. We now had a bathroom with running water, but George and I were once again without a bedroom. During the summer, we slept outside. By the time fall arrived, we had built a makeshift shed at the back of the property and used this as our bedroom. During the winter, if it snowed, there was more snow inside the shed than there was outside. Heavy blankets and a big tarp kept us somewhat warm and dry.

After moving into town, we, as well as other people, continued to work for the farmers. Wages didn't improve. Now with the addition of house or rent payments, along with utilities, the money we earned had to be stretched even further.

Broomcorn was a popular cash crop that required hand harvesting. This was hard, hot work. Oftentimes, the broomcorn was much taller than the worker, and pulling the head of the stalk caused a sticky fluid to bathe the worker from head to feet. The "juice" was sticky and itchy. The worker's clothing became saturated and stiff as a board. All types of snakes, particularly rattlesnakes, also favored these fields.

Because pulling broomcorn was no easy task, it demanded large crews of workers. Even though several families had come in from central New Mexico, there was still a shortage of manpower. Crews came in from Clovis, but the demand for laborers exceeded the supply. The answer to the problem was solved when H.T. Moody began bringing in American Indians from the Gallup, New Mexico area. Those people worked long and hard all harvest season and then returned to their homes.

My experience in the broomcorn field was limited but enough to let me know that I did not want to do that type of work for very long. The cotton fields were not any better. Being attached to a twelve-foot-long cotton sack was not my idea of earning a living. There were men and women who could "pull" several hundred pounds of cotton per day. Earnings were two

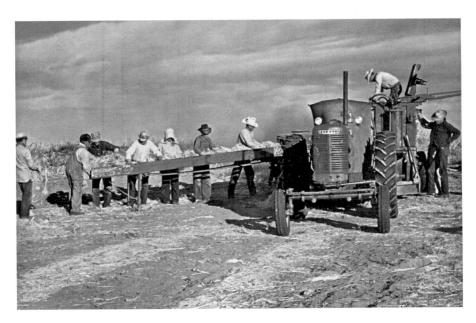

H.T. Moody's broomcorn threshing crews. Although these workers were Native Americans brought in to do this labor, our group was responsible for harvesting broomcorn also. *Courtesy Nicki Slatter collection.*

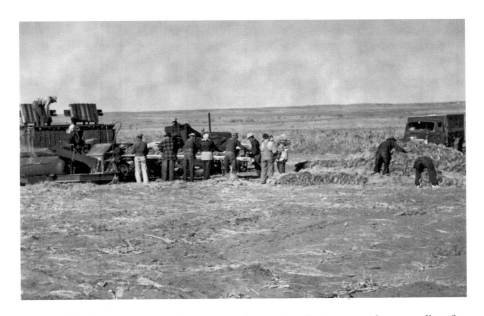

Another Moody crew harvesting broomcorn. At one time, Portales was a large supplier of broomcorn worldwide and also boasted a broom factory operated by Carl McCoy. *Courtesy Nicki Slatter collection.*

dollars per every one hundred pounds. I used the word "pull" because instead of picking the cotton boll clean of the cotton, in pulling, a worker "pulled" the complete boll with the cotton in it. After filling the sack to its full capacity, it was carried to a scale for weighing and unloading onto a wagon. Although some workers could make a reasonable wage doing this, try as hard as I could, if I achieved fifty pounds per day, I considered it a good day. The cotton fields were not very productive for me, and again, my time in the cotton fields was limited.

Some of the men who owned pickup trucks outfitted them with homemade campers and contracted with the farmers to take workers out to the fields for whatever work needed to be done. The farmers paid the pickup owner an amount for each person to whom he delivered, and the contractor became the field boss. In addition to what the farmers paid the contractor, the field hands were also charged a percentage of their hourly wages for the transportation. Mike Chávez was one of these contractors. He was a very good field boss and very fair to the field hands.

"Blackie" McKay was an Anglo contractor who hauled workers, mainly green bean pickers, out to the fields. On a couple occasions, I rode on that truck. There is one particular incident that took place when I rode in his truck that stuck in my mind for years. There was a boy, about my age, named Dempsey Herpatch, riding the truck. He was always smoking. He kept offering me a smoke; for a few days, I refused. But finally, I decided to try it. He had a sack of Dukes roll-your-own smoking tobacco. He showed me how to roll a cigarette, or something that resembled a cigarette. I lit up and coughed and almost died. That was the most terrible tasting thing I had ever tried. But I was a big boy and wasn't going to give up. I kept trying until it became easy. Before long, I was carrying a sack of Dukes or Bull Durham smoking tobacco in my pocket. When I could afford it, I graduated to tailor-made cigarettes. I became a full-fledged smoker.

Years later, I cursed the day I met Dempsey Herpatch. But I finally realized that he was not to blame; I was a willing learner. I continued to be a smoker into adulthood, finally quitting of my own free will.

As more and more people moved in, the fieldwork that had brought us to this area was becoming mechanized. Wilbur Wallace and other inventive farmers had begun experimenting with methods of mechanically harvesting the peanut crop. Eventually, Wallace came up with a machine that would turn the plants over on a thrasher. With this in mind, the men began seeking other means of employment. They realized that most jobs that would be available would be menial and low paying.

My father found a job with an implement dealer as a handy man, a job that he held for quite a few years. The implement dealership was initially located on Main Street in downtown Portales. In time, the owners, the Schumperts, expanded the business and relocated to the northeast edge of the town. Although the business continued to deal mainly in farming implements and tractors, it gradually began to encompass the field of entertainment and eventually became a bowling alley and a roller skating rink. My dad, along with Gibb Davis, were the two long-term employees. Their jobs included building the pins for the bowling alley and maintaining the equipment. The bowling alley and the skating rink were the social centerpieces of the community for many years.

As the economy dwindled and age and health issues developed, Schumpert decided to dismantle his entertainment enterprise. The property was sold, and other businesses occupied the space.

The closing of the two businesses meant that my dad had to find other employment. His former co-worker and friend, Gibb Davis, had found a job with Eastern New Mexico University in some capacity. Through Davis's efforts, my dad was hired as a groundskeeper. The university had recently built a new gymnasium complex in the shape of a huge Chinese coolie hat. Surrounding the complex was a steep hill covered by grass. His job was to keep the grass mowed, watered and healthy. He became very dedicated to his work, and the outside of the arena was kept immaculately clean and manicured. Nobody was allowed to set foot on the grass. My father held that job until he retired at the age of sixty-two.

Sometime during those years, a new business came to Portales. Selected Casings (also called the Gut Factory) prepared casings for different types of sausage. The company employed many people and provided a source of income. The work was not the most desirable, and working conditions were not ideal. But it was employment. That industry lasted several years and then relocated to Mexico, where there were lower operating costs.

My mother was a stay-at-home mom until a few years later, when, out of necessity, she became a housekeeper for several different households in Portales. Other members of our original group found employment in different areas. Orlando Ortega and his family began working for different construction contractors. Orlando's brother, Salomon Jr., began working in masonry in the construction field. The Encinias family also became brick masons. Some of these early employers were Melvin Schumpert, owner of an implement company that later to diversified into a bowling alley and a skating rink; Bob Ross and "Nub" Burke, both building contractors; and Marlin Truelock, a

Portales Selected Casings Plant (also known as the Gut Factory). *Courtesy ENMU Special Collections, Golden Library.*

masonry contractor. The people working for these companies learned their trade well and, in later years, became contractors in their own right.

Some of the men obtained employment with different businesses in town. Alfredo Madrid—who, although not with the original group, had moved his family to Portales after being discharged from the armed services—began working for the A.D. Ribble lumber company, along with Marcellino and Andres Garcia. These three men worked together for many years. Some men became concrete workers, generally as laborers.

Although several of the group sought and obtained different types of employment, a majority of the group continued to be employed in the agriculture arena. Some, like Filliberto Montano and his family and the Gallegos family, purchased small acreages and began small farming operations themselves.

My tenure in the agricultural arena came to an end when one spring day, I was setting out sweet potato slips for Roy Swafford. He approached

and asked how much we expected to be paid. I replied that we wanted seventy-five cents per hour. He replied that he would only pay fifty cents per hour. I decided then that I was not going to break my back for fifty cents an hour. I threw down my stick and walked into town. Determined to find some type of work, I went from business to business asking to be hired. Finally, I found a job in a grocery store–fruit stand. I remained with this job throughout my high school years and beyond. The pay was fifty cents an hour, and the only raise I ever had was a ten-cent raise. The reason that I got that raise was because the storeowners decided to hire a second person. They hired a boy who was enrolled at the local college. Because he was going to college, he was to earn sixty cents an hour. He was to have Sundays off and also any day that he needed to be off for college activities, including ballgames.

I had never been given a day off. I worked after school until ten o'clock and all day on Saturdays and Sundays. During the summer, I worked from five o'clock in the morning until ten o'clock at night. This included all holidays, even Christmas. The store did a lot of fresh produce marketing. The store building was small, and during the summer, the stock of produce was placed outside. What was not sold during the day had to be moved inside at closing time. That was part of my job. Oftentimes, truckloads of watermelons, Irish potatoes, fresh peaches or plums would arrive. In those days, many housewives canned or preserved the fresh produce themselves. The produce was unloaded outside, and if they weren't sold during the day, I had to carry them in before I was allowed to go home for the night. The next

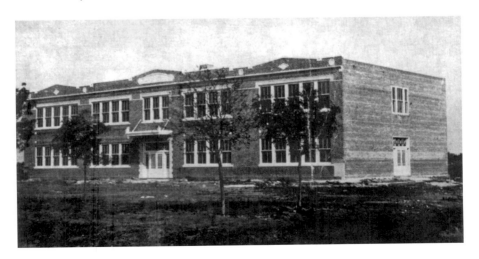

The old Portales Junior High School. *Courtesy ENMU Special Collections, Golden Library.*

morning, I would carry them back out. Needless to say, I became a pretty successful salesperson.

While I was going to school, now in seventh grade, my teachers were not very motivating, and my grades began to decline. The teachers' attitudes had remained the same as when my sister Rita had first enrolled there. We were given as little attention as possible. In all of my school experience, I was never assigned or given access to an advisor or school counselor. I wasn't even aware that there were counselors in the school. The only time I saw the office was when I was in trouble, which was often.

I didn't do anything serious—other students did the same things and nothing was thought of it. But I ended up in the office. My behavior continued to get worse. Junior high school was becoming a lost cause. The only reason I continued even going to classes was because my parents would have never allowed me to even consider dropping out. Both of my parents had only minimal education, fourth grade or less. My grades were all failing, and my progression to the next grade was always in doubt. But when the standardized tests came around, I knocked the top off them. My scores were equivalent to three grade levels higher than my present grade level. Thus, I always found myself advanced to the next grade level.

My junior high math teacher was the only teacher who showed any interest in me. He kept insisting that I come in after school for special tutoring. I reluctantly submitted to his suggestion, and indeed, he helped me a great deal. Later, I was enrolled in an algebra class. The algebra teacher was not very competent in the subject and had very difficult time teaching the class. I approached the math teacher, Aubrey Davis, and explained to him that I was fearful of failing algebra. He tutored me, and in time, the subject became easy for me. The algebra teacher became outraged and accused me of cheating, but I passed.

During that year, a polio epidemic spread throughout the nation. Portales was not immune. When we went to school, we didn't know who would be there. Every day, somebody was stricken and had to be hospitalized. A new vocabulary sprang up. Words like "iron lung," "bulbar polio" and "DDT," the latter to combat mosquitoes. DDT later managed to get into the underground water source and had to be banned. Polio was a real threat until Dr. Jonas Salk developed a vaccine for it. Until then, several classmates were seriously crippled by it. To our family, it was nothing new, as two of our family members had contracted the disease years earlier.

By this time, the Hispanic school population was steadily growing, though not so much in the upper grades as at the elementary level. Lindsey

Elementary, located in north Portales, was beginning to acquire quite a few Hispanic students. East Ward and Central Elementary had none. At the junior high school, there were several Hispanic students enrolled. I began attempting to communicate with those students. Having made the transition from Spanish to English, I now realized that I had become a "limited Spanish speaker." That made me an outcast with the incoming Hispanic students. By this time, I had been accepted by many of the Anglo students, and all the people I ran around with were Anglo. The Hispanic students detested that, so I was between the proverbial rock and hard place.

George was a grade ahead of me and had become quite a basketball player. He was smaller than the other players, but his speed could not be matched. While he was in the eighth grade, he was playing for the high school B team and was chosen for the all-county team. During his ninth grade year, he played for the high school varsity team. At the end of that year, during commencement exercises, the student were lined up in alphabetical order. Earlier that year, a family by the name of Romo had moved in from Roswell, New Mexico. A daughter of that family was to be in the commencement ceremony. She was in line ahead of George because of the alphabetical order. Coach Lloyd Jackson, the junior high school coach noticed, and he took George by the arm and placed him in line in front of the girl and said, "George you have been going to school here for most of your school life; you are going first." That made George the first Hispanic to walk across a commencement stage in the history of Portales.

George began dating a girl while in high school. She graduated a year or so before he did. Her parents were not very happy about the situation, so as soon as she graduated, they shipped her off to a private, very elite school in Colombia, Missouri. That did not deter the two from corresponding with each other. On one occasion, he made the trip to Missouri to see her. Eventually, she returned to Portales. Their separation had not served the intended purpose.

George graduated and, the following fall, enrolled in the local college. His college experience did not prove successful, and he dropped out after one semester. He began working in a gasoline service station. He continued to see the girl, much to the chagrin of her parents. Unexpectedly, they eloped. They kept their marriage a secret, and it was only discovered when the county clerk from the county where they were married mailed the marriage certificate to my parent's address and my mother accidentally opened it. The girl whom George married was the daughter of the mayor of Portales.

George Trujillo (far right) at work at Hatch Packing Company. *Courtesy ENMU Special Collections, Golden Library.*

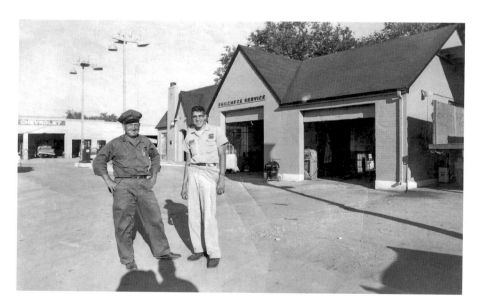

George Trujillo (right) was employed as a service attendant after completing Philips 66 training. *Author's collection.*

The school years progressed, and I found myself in high school, still with no goal to aim for. I took classes because I was supposed to. I did manage to get myself into a mechanics class. I did quite well, and the class was three hours long, which suited me. I only had three other classes to worry about. The mechanics teacher was very competent at his job, and even though I did not have a vehicle to work on, I gained a good basic knowledge, which I figured I could use later on in life.

The three other classes that I had to take proved to be my undoing. Try as hard as I might, success seemed beyond my reach. One memorable experience during my high school years was when the mechanics teacher, Mr. Meadors, took the entire class to Mexico to see the final leg of the Pan-American cross-country road race. I was on the verge of not being allowed to go, supposedly because of my grades. In those days, there wasn't a "no pass, no play" school-wide rule. But a particular teacher enacted that rule just for me. What finally made it possible for me to make the trip was that the mechanics teacher and all my mechanics classmates petitioned for me, and the teacher relented under the pressure. The trip was the highlight of my high school career. I was the only Spanish-speaking student on the trip, and even with my fragmented Spanish, I became the official translator while we were in Mexico.

Although there were some very good teachers in the system, there were several that were not yet accustomed to teaching non-Anglo students. I was repeatedly reminded that my only vocation in life would be that of a laborer. I was constantly told by teachers, not educational advisors, to take as many vocational courses as I could because I was destined to dig ditches for a living. Later in life, some people said that maybe they were only trying to motivate me. Well, if they had been there at the time, I doubt they would think that.

Perhaps the most memorable and devastating incident that both George and I experienced was with the Portales Country Club. While in high school, several of our friends would go to the club and serve as caddies for the local golf players. This gave them the opportunity to earn a few dollars of spending money. We were asked to accompany several of the students one Saturday morning. We arrived at the club and were eager to learn the caddie business. The man who was in charge of the club approached George and me. He told us that we were not allowed at the club for any reason. We were told to leave. We left, and to this day, I have returned on only two occasions: one when I was given a party there and the other when one of my daughters was married and the reception was held there. Things have changed there,

and there are multiracial golfers and perhaps members. But I have no desire to play golf or be a member of that organization. George, up until the time of his death, never patronized that place either.

Years before, I had read the book *Battlefront*, a book about the Marine Corps. I determined then that, as soon as I graduated from high school, I would join that elite branch of the military.

The class of 1956 included Carmen Baca, Virginia Encinias, Martin Moreno and myself. Virginia and I were the earliest Hispanic arrivals to Portales. Carmen and her large family came from the Villanueva area. Virginia and her family had come from the small rancho near the small village of Dilia, New Mexico. Martin Moreno and his family migrated to Portales from the Marfa/Alpine, Texas area. Virginia and I had attended school in Portales from early elementary on through our senior year. There was another girl in the class, Manuela Aguilar (Mae); she had arrived in Portales during her high school years. I did not know where she or her family came from.

I had progressed through high school haphazardly, going from grade to grade with barely passing grades. At the end of senior year, as graduation was at hand, I was not with my classmates. Three weeks before graduation, in a class discussion with other students and an English teacher, a teacher had made a comment about Texas and the Alamo. Other students joked about it. I commented as well, but my comment was not taken as jokingly as the others. I found myself in the principal's office again. I was suspended for the remainder of the year. The English teacher failed me, and I was not allowed to graduate.

Not being able to graduate with my class was the worse thing that the English teacher could have done to me, and she knew that. My self-esteem was zero, and I felt completely useless. My parents were very disappointed in me. They had never been consulted about or informed of the situation. The expulsion was the sole decision of the principal and the teacher.

I spent that summer in mental turmoil. By the time school began in the fall, I had determined that I would return to school, retake the failed class and graduate. The principal refused to place me in the class and insisted that I take another class instead. I refused and insisted that I be placed in the same class with the same teacher. I won out and attended school for one hour a day, completed the coursework and passed. At the end of the year, I graduated and obtained my high school diploma.

I graduated from high school, but it was a bittersweet victory. I had not graduated with the class that I had been with from first grade through senior

year. I never attended any of the class reunions with the class I began with or the class I graduated with. I felt I didn't belong with either. The teacher who caused me to have to repeat one class is no longer living. Many considered her a "wonderful" educator. May she rest in peace.

For many years, I was very bitter about my educational experience. As time went on, my thinking changed. I determined that perhaps a lot of the problem had been my fault because of my attitude. It was too late to change the past. But the future was mine.

The year was 1957. Although there was still plenty of fieldwork in Roosevelt County, most of the families that had arrived in 1942 were now living in town. The attitude of the townspeople was changing. We were now accepted in the stores and other businesses. Jobs were opening up and living conditions were improving. Other families were moving in, and the families that were already in Portales were gaining a foothold. They owned their own small farms and gained employment in businesses that gave promise to the future.

Having completed high school, I was convinced that I would never succeed in the higher learning arena. I continued working at the grocery store, earning the same wages that I had been for so many years. I felt that I was doomed to this humdrum existence as long as I remained in Portales. I was on a one-way street to nowhere. From May until July, I worked and pondered how I might escape this prison.

On the first day of July, I went to the basement of the local post office. All the military recruitment offices were located there. I went into the Marine Corps office. There was nobody there. A navy recruiter approached me and told me about all the navy had to offer. I told him that I would join the Marine Corps or nothing. He told me that I would be sorry, but he picked up the phone and called the recruiter in Roswell. He told me to be back by three o'clock that afternoon. When I returned, a marine met me and told me that I was not fit to be in his Marine Corps. He told me to go see the navy or army recruiters. I told him that I didn't want to join those branches and turned to leave. As I was going out the door, he yelled, "Get back here!" He signed me up. On July 14, I boarded a Greyhound bus for Albuquerque for a physical test and induction into the United States Marine Corps.

On the bus, there were twenty-five Marine Corps hopefuls, but we had to pass the physical first. The physical was to take place the following morning. The minimum weight was 130. I weighed 125. That night, I went out and bought a big bunch of bananas and a gallon of milk. I consumed the bananas and milk. The next morning, I had half a pound to spare. Of the twenty-five

hopefuls, only two passed the physical—me and another underweight boy who looked like he had been kicked in the chest by a horse.

That evening I boarded a plane (my first ever) for the Marine Corps Recruit Depot (MCRD) in San Diego, California. It was the very first time I had ever been outside New Mexico in my life.

Marine Corps boot camp in 1957 was twelve weeks of pure hell. I will not go into the particulars of my experience in boot camp. Unless you have been there, you won't believe what happened. I made it through boot camp and became a full-fledged marine. The Marine Corps during peacetime is not a good place to be. Promotions are slow and, for the most part, training is dull. I was stationed in Oahu, Hawaii, also not the best place to be at that time in the military. Salary for a marine private was eighty dollars per month. In Hawaii, that amount didn't go very far. I was assigned to a naval ammunition depot at Waikele, outside Waipahu. Waikele was the storage area for all the nuclear weapons in the Pacific area. The marine detachment was a spit-and-shine guard unit. When we were not standing guard, we were doing formal guard mounts, or formal parades, for all the big military brass from Pearl Harbor. The base was a restricted area, and I had to obtain a "top secret" clearance to be stationed there. The base was closed and declassified in 1990. Before that, the base was top secret and separate from the Marine Corps; all men who were stationed there were debriefed with orders never to disclose its existence or whereabouts. On its declassification, we were informed that we were released from that order.

On the completion of my tour, I was sent to San Diego for reenlistment or separation from the corps. I was considering reenlisting for six years and making a career of the military. While I was in separation status and maneuvering for more rank and choice of station, I got a phone call from my parents telling me that my cousin Martin had passed away from cancer complications. I took my mustering out pay and bought a plane ticket to Albuquerque in an attempt to be in Portales for the funeral. I landed in Albuquerque but was unable to get to the funeral. When I finally got to Portales, I knew my tenure in the marines was over.

On my return to Portales, my old boss offered me my job back with wages beginning at one dollar per hour. I accepted the job, as there was nothing else available. I looked for other types of employment and was unsuccessful. I remained in Portales for one year. I bought my first car, a new 1961 Ford Sunliner. Shortly after that, I met my future wife, Amelia, the daughter of the Villanueva family that had come to Portales shortly after my family.

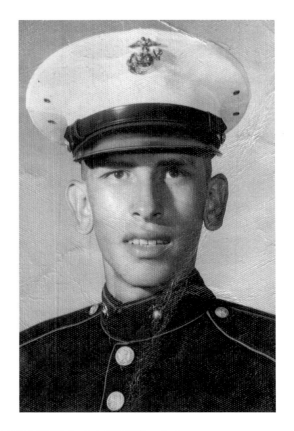

Right: Marine Corps picture of the author. *Author's collection.*

Below: Amelia Villanueva Trujillo (front), the author's future spouse. *Author's collection.*

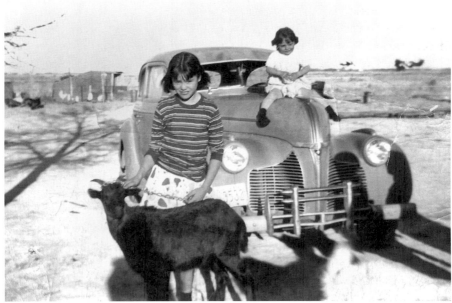

In June, I decided to apply for a job at the New Mexico state penitentiary in Santa Fe. I was accepted and left Portales for the second time on July 4. In Santa Fe, I went through the training to become a correctional officer. Working in the penitentiary was a very depressing experience. The inmates—most of whom were good men who had made some wrong choices in life—were easy to work with and very cooperative. The few hard-case inmates were too concerned with staying alive in their hostile environment to give any trouble. Generally, the main concern for the correctional officers was to endure the boredom of the job. There was one small riot among the inmates, but it was easily controlled. This was a prelude to the large-scale riot that took place shortly after I decided that being a correctional officer offered no real future. After four months, I tendered my resignation.

There is one incident that happened while I was living in Santa Fe that I will never forget: I and two of my cousins were driving west on Barrio De La Canada Street one evening. I had the car window down about three inches. Somebody took a shot at me. The projectile hit the metal at the top of the glass, which deflected it, but it hit the earpiece of my eyeglasses, threw me across the car and knocked me out. Somehow, I managed to control the car and brought it to a stop. My cousins took me to the emergency room where I was examined and released after ascertaining that the bullet hadn't penetrated my head. My eyeglasses had saved my life. I was still working and living at the penitentiary at this time. When I returned to my dorm, my inmate valet summoned the prison priest, who took me to the prison infirmary. An inmate doctor and nurse worked on me throughout the night. My head was swollen to twice its normal size. Although the projectile had not penetrated into my head, the concussion had caused my head to swell. My eyes were black and the pain was unlike anything I had ever suffered.

Once again, I returned to Portales. I immediately began my search for employment. Unable to find employment in town, I resorted to doing the type of work that was the least desirable to me—fieldwork. I worked at everything I was offered, from loading bundles of feed on trailers to loading hay bales on trucks. Luckily, when I came home from work a few weeks later, the manager of Portales Lumber Company had called needing a yard hand. The next morning, I was there, ready to go to work. The pay wasn't too good and the work was hard, but it was a job. The manager, Alton Sadberry, was a perfectionist and very demanding. While working for that company, I used my math skills extensively. Sadberry insisted that everything was to be worked out, including board feet of lumber.

I was employed there for three years. During those years, Amelia and I got married. I got to take off the Saturday on which we married but went back to work on Monday. After I left that job, I worked with another lumber company and got a raise in salary. The previous employer had never thought it necessary to give anybody a raise. My new employer had lumberyards in Portales and Clovis. When he had to close the Portales store, he moved me to the Clovis store. There he made me his bookkeeper. I really enjoyed that job and learned all aspects of being a bookkeeper.

The Law Enforcement Years

While still living in Portales, I had approached the police chief Lloyd Moore about the possibility of being hired as a police officer. He laughed at me and told me not to waste my time or his. He said, "Portales would ever accept a Mexican police officer." That totally blew my confidence.

One morning while I was working, a motorcycle police officer came into the store and asked for me. He said, "You need to come with me." I told him that I had done nothing wrong and that I wasn't going with him. He broke into a grin and told me that the police chief wanted to see me. My boss allowed me to take off for a few minutes, and I went to the police station. Chief of police "Dusty" Rhodes told me that he wanted me to join the Clovis police force. Unknown to me, two officers—Norvell Fraiser and Tommy Bell, both Portales natives—had convinced Chief Rhodes that he should hire me. They felt I would make a good police officer. I gave two weeks' notice to my employer, and two weeks later, I began working undercover in Clovis, New Mexico.

Captain Bill Bollinger was in charge of the detective division, so I was under his supervision. I worked undercover for six months. During that time, I was instrumental in several large drug stings, including the arrests of several Mexican cartel drug dealers and mules.

After the undercover work, I went into training and became certified by the New Mexico Police Academy, a certification that I hold to this day. I was employed with the Clovis Police Department until 1968. At that time, politics came into the mix, and Chief Rhodes was forced out of office in a

power play by a group of city councilmen. When he left, the city hired a hotshot pistol bum as chief—Kenneth Kingsbury, a police officer from Las Vegas, Nevada, formerly of Albuquerque. Immediately after he came in, I came under pressure. I had been primarily assigned to the west side of the town. That area was mostly Hispanic and black. It also had the highest crime and violence rate. Drugs were beginning to move into the area. A Mexican drug cartel had gained a foothold, and drug trafficking was increasing. I had developed a good number of informants and was instrumental in several large narcotics arrests. The new chief called me in and demanded that I give him access to my informants. I refused, and after that, my days with the Clovis Police Department were numbered. It became apparent that either he left or I left. He was the golden child of the city council, so I was forced out.

During my tenure with the Clovis Police Department, a radio dispatcher, Jose Garcia, encouraged me to begin going to the local university. By the time I left the force, I had enrolled at Eastern New Mexico University and had finished one semester. I returned to Portales with the intention of continuing with my studies and working at whatever I could find while I was going to school. I did not intend to go back into police work.

I began doing odd jobs—yard work or anything else that would bring in an income. I had a family, my wife and five young daughters, to take care of. Our house was a small, two-room residence, and I began adding on. With no steady income, I found that the only way I could obtain materials was to salvage discarded goods. On my second day back in Portales, I was offered an unoccupied house to dismantle for materials. I was in the process of dismantling the house when a police vehicle pulled up and the chief of police, Pete Heisch, got out and asked me if I would join his department. I told him that I would consider it, and he asked how long I might need to consider. I asked him when he would want me to begin. He replied, "Tonight." He added that I could go to the police station and select a uniform that would fit me until they could order some for me. That night, I became the first Hispanic law enforcement officer in the history of Portales and Roosevelt County. That is when the fun began.

When I began working in Clovis, I was unknown, which enabled me to work undercover for an extended period of time. In Portales, everybody knew me. The Hispanic population called me an "Uncle Tom," and to the Anglo population, I was an "uppity Mexican." The other officers in the Portales Police Department detested the idea of me being on the force. I found that if I were to survive in this department, I would have to develop

a sixth sense and protect my back at all times. This thought proved true the second week I was on the force.

While on patrol one night, a vehicle flagged me over. A woman got out and said she wanted to talk to me. I said, "OK," but she told me to meet her somewhere else. I agreed and went where she suggested. When she arrived, she produced two open beers and offered me one. The area was well lit and observable from several vantage points. I told her that I was on duty and that I didn't drink on duty. I began to recruit her as an informant. We both left the area, she taking her beer with her.

Several years later, a fellow police officer, Jim Griffin, approached me. We were both sergeants by that time. He said, "Pete, I have something to tell you."

"Pete, Officer ———— and I tried to set you up when you first started working here. We were afraid you were going to get all the promotions." He went on to explain.

I told him that I was aware that he had tried to set me up. The woman had become a valuable informant and had told me long before. The second officer is still alive. He knows who he is, but I won't mention his name.

Sometime later, he tried to set me up again. That time, I was to be lured into a high-speed chase out of the town, where the vehicle would stop and I would get a beating. I knew the driver of the vehicle, and before he got out of the city limits, I pulled in front of him, blocking the road. He had been drinking and was arrested. I later learned about the plot. Not long after that, Officer ———— resigned and went to the state police. He didn't last long there.

There were some good men on the Portales force, but the uniformed officers who worked the graveyard shift were very insecure. The shift sergeant, Jim Killion, was a good supervisor. However, he was not there very long after I was hired. I chose to work the graveyard shift in order to continue with my university studies.

I enjoyed being in the Portales Police Department. The population accepted me, and I carried out my duties without regard to nationality. If a law was broken and an arrest was warranted, an arrest was made. Within the department, things were little improved. I knew that if I went on a call, I might have a backup or I might not, depending on who was on duty. In less than a year, I was promoted to the rank of sergeant. Several of the officers resigned. As a supervisor, I treated everyone with respect and did not expect them to do anything that I would not do. My orders were followed, although sometimes not willingly. I was a field supervisor and patrolman. I took calls and gave backup on other officer's calls. I was called on to make decisions on

arrests and all aspects of law enforcement. Apparently, I was doing it right, because a year later I was promoted to the rank of lieutenant. While I was working in Clovis, Sheriff Nelson Worley had made me a deputy sheriff in Curry County. When I resigned from the Clovis Police Department, I also tendered my resignation to Sheriff Worley. He declined my resignation and told me to continue as a special deputy for the remainder of his term.

On my employment with the Portales Police Department, Sheriff Glenn Widner also made me a special deputy. I was then a dual-county deputy sheriff. To my knowledge, that is the only time that has ever happened in the history of both counties.

Those days were not the best for law enforcement, not only in Portales but also throughout the entire nation. Civil rights were at the forefront, and every community, large or small, felt the impact. While Martin Luther King Jr. was marching and protesting in the larger cities, we were experiencing the same thing on a smaller scale. In communities with institutions of higher learning, such as Portales, there were protests and unrest. The black population was still minimal at best. However, another faction was rearing its head.

The Hispanic community attending the university felt discriminated against and began protests. The protest centered on the university president. Hispanic students conducted a peaceful sit-in and refused to leave. Law enforcement was called in, and I had to make a decision. As a student, I too had experienced discrimination. Was I going to carry out my sworn duty and enforce the law or excuse myself? As a Hispanic police officer and a university student, I was given the choice by the chief and the district attorney. I chose to be a police officer and gave the order to vacate the building. Some of the protesters were handcuffed and had to be carried out. I felt their scorn on my return to classes.

Shortly after that incident, a small Hispanic girl accused a merchant in north Portales of indecent actions toward her. He denied the allegations, and in those days, if there were no witnesses, it was her word against his. In that instance, his word prevailed. Some of the Hispanic community objected. Their objections fell on deaf ears. As a result, they began demonstrating and picketing the merchant's business. A supposedly nonviolent, paramilitary grass-roots organization—the "Brown Berets"—sprang up and joined the demonstration. Some non-Hispanic citizens found these actions unacceptable. Tensions were running high.

The district attorney at the time, Morris Stagner, fearing a violent outbreak, had brought in some extra state police officers. One of them was from Portales. That officer apparently had never been schooled in public

relations. When the crowd moved on city hall and the police station, he began calling the protesters names and in general making matters worse. I eventually had to tell him to cut it out or I would arrest him for disorderly conduct. I was off duty when the major confrontation took place, and I was called in. I went dressed in my street clothes. As most of the protesters were non-English speakers, I stood next to the district attorney and attempted to appease the crowd. With the Brown Berets urging the crowd on, appeasement was impossible. After the crowd of people refused to disperse, the police told them that they would be arrested. When the crowd threatened violence, the arrests began.

The county jail was located on the third floor of the county courthouse. Those arrested were taken up via a very decrepit elevator. One particular elderly woman became violent and was handcuffed and put into the elevator with several other people. When she arrived at the third floor jail, she was cuff-less. Somehow, she had freed herself from the handcuffs. The handcuffs were never located.

While assisting with the booking, fingerprinting and transportation of the arrestees to the jail, I (still in street clothes) was shoved against a wall, frisked and handcuffed by one of the state police officers who had been brought in. I would have been jailed had the police chief not yelled out to him, "He is one of my men!" After the arrests and subsequent trials, the atmosphere cooled off, and the irate citizens took their cases to court rather than the streets.

Final Career Change

Icontinued working on the police force until I completed my degree. I intended to complete a bachelor's degree and then go to law school. I had applied to the Oklahoma City University law school and been accepted. However, something happened that changed my career plans. I was having a conversation with a fellow student during one of my political science classes, and he said that I should go into education, especially elementary education. He said that if I did, I would practically have a job the moment I graduated. I didn't give it much thought, as my mind was set on law school. That very night, he suffered a massive heart attack and died. When his death was announced the following class session, I was stunned. His words kept going through my mind. The following semester, I changed degree plans and was accepted into the school of education. The following May, I completed my studies and became a certified elementary school teacher.

I continued working on the force, thinking I would be a police officer until I could no longer do the job. The political atmosphere in a small community constantly changes. Generally, the first entity that the small-time politicians go after is the police department. After considering the monetary aspects, I learned that although education would not be too much of an improvement money wise, the benefits were substantially better. With that in mind, I applied for teaching positions in the Portales Municipal School District. There were quite a few openings, but I didn't even get an interview. I was resigned to remaining on the force.

In midsummer, I got a call from a superintendent in a place called Datil. I had no idea where that was, and I told him so. He explained where it was located and invited me to visit the area at his school district's expense. I figured I had nothing to lose. Two weeks later, my wife, my brother Joe and I drove to Datil.

Datil, New Mexico, is located at the western edge of the San Augustine Plains, almost as far west as you can go in New Mexico. The village had maybe twenty-five residents. It boasted a three-room schoolhouse. The superintendent, Mr. Dooley, met us there. He explained that, should I accept the position, I would be the principal, classroom teacher and coach. He also explained that the school district also offered a teacherage, a small two bedroom apartment, for a reasonable price. Reluctantly, and after consulting with the wife, I agreed to take it on for at least one year. The contract was signed with the understanding that it could be cancelled should I change my mind.

On returning to Portales, I tendered my resignation to the police chief. In August 1974, we packed our belongings and left Portales once again. Pulling a U-Haul trailer with the family car, we headed to Datil. We made it about 150 miles before the weight of the trailer proved to be too much for the car. The transmission gave out. We called a tow truck and were hauled back to Roswell, New Mexico. Repairing the transmission was going to be costly, so we began shopping for a different vehicle. A dealership told us that they didn't have anything on hand. The salesman, who looked like he had been imbibing, said there was a pickup truck being traded in that afternoon, and if we wanted, we could wait on it. So, we decided to wait. The salesman, anxious to make a sale, suggested that he write up the paperwork now, and when the truck came in, we could sign. If we were not pleased, we could just void the deal. He gave us a price, and we agreed. About three o'clock that afternoon, a beautiful Dodge crew cab pickup truck pulled up. The salesman's jaw dropped. We signed. The truck was an immaculately kept, late-model vehicle with less than three thousand miles on it. The salesman could have sold it for four times what he had offered it to us for. But he stuck to his deal.

We arrived at Datil and began our adventure there. It was wonderful year. I learned a lot about education and had a wonderful supervisor and staff of six people. The school board attempted to push its weight around. Mr. Dooley, the superintendent, was quite elderly, and the board had been able to have him do their bidding. Me, being new to the field of education and having been used to giving orders rather than taking them, proved to be too much for the board. Consequently, I got my way. The year was very

enjoyable, and despite the isolation, the family unanimously agreed to return the following year. Another contract was signed. At the end of the school year, we returned to Portales. I had enrolled in classes, working toward a master's degree.

During the year that I had spent in Datil, a lawsuit had taken place—*Serna v. Portales School Board of Education*—in which Judy Serna's mother claimed that the Portales schools practiced discrimination toward Hispanic students. There were no bilingual classes and no teachings of their customs and heritage. The court found in Serna's favor, and the Supreme Court upheld the lower court's ruling. (That court brief will be in the Appendix). The court ordered Portales schools to, among other things, hire bilingual teachers and begin a bilingual program.

I was taking classes toward a master's degree, and my family was doing fieldwork to supplement my income as a beginning teacher. One afternoon as I was sitting at a typewriter working on a class paper, a man knocked on my door. I answered the door, and he introduced himself as George Hughes, assistant superintendent of Portales schools. He asked if I might be interested in a teaching position with the Portales Municipal School System. I told him that I was; however, I had already signed a contract with the Datil school. He told me that there would probably be no problem getting the Datil school to release me from that contract. He said he would call them and take care of it. He presented a letter of employment, and I was hired by the local school system. I didn't even have to submit an application. I later learned that there were several other Hispanic teachers recruited, including Vangie Encinias and Trina Valdez. We were the first non-Anglo educators in the Portales schools. A man from Clovis, a Mr. Carrasco, was hired as the director of bilingual education.

The bilingual program was nonexistent, as no curriculum had been developed for it. There were no set methods of instruction. Mr. Carrasco felt that bilingual education meant teaching conversational Spanish. Eastern New Mexico University did not have a bilingual program because bilingual education had not been instituted prior to that time. I and the other recently recruited teachers were labeled bilingual teachers without bilingual certification.

As the school year began, I was assigned to the J.P. Steiner School. This was the same school I had attended during my elementary school years. It was formerly known as East Ward Elementary. I was to implement a bilingual program as a bilingual teacher. I had never had a single class on bilingual education. In my first class, there were around thirty students. There were

maybe two Hispanic students, all of them fluent English speakers. The rest of the class was totally Anglo.

I was to instruct in English and teach all subjects across the curriculum. This meant teaching math, reading, grammar, social studies and spelling. In addition, I was to teach conversational Spanish. The bilingual director would come around on a daily basis and supposedly enhance and evaluate my teaching strategy. In reality, he had no idea how to instruct in either language. Thus, I struggled for two years. I managed to develop a curriculum that was acceptable to the administration. For both of those two years, I received exemplary ratings from the building principal.

After two years, the supervisory arm of the court intervened and mandated that Portales schools must cease the practice of segregation. Until that time, the schools were going on the premise set by the *Plessey v. Ferguson* court case stating that segregation was OK as long as the concept of "separate but equal" was maintained.

Portales schools then went through a process of reorganization, shifting students to different schools and using buses to transport them. The restructuring was to be implemented the following school year. Reorganizing would move first-grade students to J.P. Steiner, second- and third-grade students to L.L. Brown, fourth- and fifth-grade students to R.M. James and sixth-grade students to Lindsey. All of these were designated elementary schools.

Prior to the reorganization, every elementary school housed grades one through six. On completion of the sixth grade, the students were sent to the junior high school. Since the students didn't know one another, there were many conflicts. The junior high school became a virtual battlefield, especially for the students from the Lindsey school. Until then, the Lindsey school had been almost totally Hispanic. The year before reorganization, there was only one non-Hispanic student there. The students at the other schools were reluctant to make the move. Many voiced their concerns. It was difficult to make them understand that because of the reorganization, there would be a heterogeneous group of students at each school. Still, many students thought they might be moved to Lindsey, and they had been more or less brainwashed into believing that bad things happened there. Actually, the atmosphere at that school was geared more toward learning because the students knew that they had to work harder.

Prior to school being dismissed for the summer, each teacher was reassigned to the school that they were to teach at the next year. Every teacher was to pack all of his or her instructional materials and books in preparation for the move. I was assigned to teach fifth grade at R.M. James Elementary. I was

content with my assignment; several of the teachers were not. Some retired and others decided to leave the system. One male teacher was so discontent with his assignment that he called me and asked if I were willing to exchange with him. When I told him that no, I was satisfied with the school I was going to, he became very irritated. He yelled at me, "Why do you want to go there? They don't want you!" I was aware that the principal and some of the teachers had voiced their discontent at my being assigned there. However, I was determined to make myself known and do everything in my power to change attitudes and to make sure that every student, regardless of nationality, had an equal opportunity to learn.

I reported to the building and was assigned a room number. I searched for the room number in the fifth grade wing of the building. I could not find it. I asked the janitor if he knew where I might find that room. He told me that it was in the fourth grade wing. The janitor took me to the room. It was the only room in the building that had no windows and only one door. Previously, it had been used for a book storage room. Now I realized that what I had heard about not being wanted was not an idle rumor; it was the truth.

My dilemma was whether I should express my feelings or just play along with it? I determined that I was going to become the most outstanding teacher in not only the building but in the entire school system. The first thing I did was make that room the most attractive room in the building. Construction paper made a beautiful window, complete with sunshine and trees and birds. The scenery outside the window would change with the seasons. I spent all summer and most of my finances preparing the room for the students. I never complained, even when most of the materials that I had packed became lost in transit, never to be located. (Sometime later, I discovered some of those materials being used by another teacher).

At the beginning of the school year, the principal informed me that I was to be the bilingual teacher for the building. I informed him that I was not certified as a bilingual teacher. He told me that I was bilingual by nature, so I would be the bilingual teacher. I chose not to argue with him. As the students arrived, I found that I indeed would not be a bilingual teacher but a multilingual teacher. My class was made up of non-English-speaking Hispanic, Saudi Arabian and Indian students. I also had three Anglo students.

That year was an extremely exhausting but productive year, not only for me but for the students as well. I developed lesson plans for each individual student. While I taught the Hispanic students, the other students were working together.

Strange as it seems, when dealing with different languages in a room where one group does not understand the other, it seemed that the louder one speaks, the better he or she is understood. That being the case, our room kept getting louder and louder. By mid-year, all students could communicate in limited English. Those who were becoming more fluent assisted the others. By year's end, all were able to join regular classrooms. During that year and the previous years I taught at Steiner, I was never observed or evaluated by the building principal. I was presented with a checklist showing that an evaluation had been done. All items on the list were noted as above average, so I acknowledged the list with my signature and was presented with a letter of intent to be rehired for the following year.

That summer, I was taking classes toward a master's degree. Other people in the classes learned that I was teaching in the Portales schools and asked how I had gained a position in that system. I was informed that several certified teachers who were Hispanic had applied and were not hired. Non-Hispanic teachers had been hired on a regular basis. I began inquiring about the situation. When I approached the superintendent with my questions, he told me that I had a job and should be content and not make waves. I had studied the results of the *Serna v. Portales School Board* case, and I asked him what his intention was in regard to complying with the court ruling. He replied that it was not my concern. However, before the next school year, three more Hispanic teachers were hired. An Anglo teacher later told me that she had been promised a position that year but had been denied a position because of my "confrontation" with the superintendent.

CHAPTER 16

Progress

During this time, other members of the first group of us who came to Portales were making headway into the mainstream of the local workforce. The Ortega family, led by Orlando Sr., had begun working as laborers in the construction industry and now were licensed contractors in their own right. Orlando Ortega and Sons Construction became very successful.

The Garcia family also became well established. Robert Garcia had begun working for Morton Cragg at Portales Hardware and eventually became the owner. He also became prominent in local politics, serving as a city council member for a long period of time. Gus Garcia joined the Army National Guard and went into active duty, eventually retiring as a high-ranking officer.

The Encinias brothers Gabriel and Ruben began working in the masonry industry for Marlin Truelock. In time, they became licensed and formed their own construction company, which was very successful. A third Encinias brother, Robert, became a merchant, dealing in television sales and repair. Later, he expanded to furniture and appliance sales.

A branch of the Villanueva family—Domingo, Vincent, Robert and Richard—became brick masons. They, too, formed their own company and did very well. Domingo's wife, Ida, became a successful educator. Members of my family—myself, Sandra, José "Joe" and their spouses (Antonio O. Salguero and Sally Mae Jaramillo Trujillo)—became educators and taught in the local schools or in other schools within the state.

The Sinforoso Baca family—which included Carmen, Herman and Ike, along with other brothers and sisters—also migrated from the Villanueva

village. Villanueva is located along the Pecos River south of Las Vegas, New Mexico. The Baca family, the Montoya family and the Villanueva family originally from that locality established homes in Portales.

Of historical interest, many of the families that I am writing about were from the same general area. As most students of New Mexico history are aware, treaties agreed to and signed by the governments of the United States and other counties, notably Mexico, provided several conditions that would enable the countries to coexist peacefully. The treaty of Guadalupe Hidalgo established the Rio Grande as the border between the United States and Mexico. The treaty established land grants, which gave the citizens of Mexican descent certain land ownership rights. One such land grant, the Anton Chico Land Grant, encompasses the area around the village of Villanueva. Although not all of the people actually lived on the land grant, at one time or another, the places where they lived might have been included in the grant. At any rate, each family group was established on their own privately owned tract of land, and every family community was named accordingly—La Noria, Gonzales Ranch, La Palma and so on. One large tract of land, known as Agua Verde, had been acquired by José Ortiz y Pino, also called "Patrón," a left over title from the patrón system.[4] The notorious patrón ruled his fiefdom from his trading post in Gallisteo. He made his rounds in a chauffeur-driven automobile, going from ranchito to ranchito on "his" Agua Verde. By exploiting the small landowners, the patrón acquired extensive land holdings.

Although the people from that area may have had access to the land grant resources, earning a living from an arid land suited mainly for sheep growing became extremely difficult in times of drought. The rocky, rolling hill terrain prohibited all but small-scale farming. This was the reason for the migration of those people to the plains of Eastern New Mexico.

The Villanueva and Montoya families, along with the Baca family, began their tenure in this new environment as farm field laborers. In later years, the progeny of these families became educators and brick masons. Victor Baca, born in Portales, earned the coveted degree of pharmaceutical science and established a successful pharmacy business.

In addition to those listed, many more families succeeded in various fields, some in the services industries. Indeed, the work for which we came to Portales had, because of innovation and new inventions, been phased out. The integrity and desire to adapt that these people possessed proved that even through adverse conditions and hostility, success was possible.

CHAPTER 17

Advancements in Education

In the beginning of my second year as a bilingual teacher at R.M. James Elementary, I was told that I would be the physical education teacher that year. In addition, I would still teach bilingual classes. I told the principal that I was not certified as a physical education teacher. He told me that the order had come from the main office and, if I had any questions, to take them to the superintendent. Again, I decided to just go along and continue to do the job.

That was the worse year I had in my teaching career. I was aware of what was going on. The other teachers who did not make "waves" were not experiencing what I was. I taught the physical education classes as well as I could. That meant teaching every student in the school, developing lesson plans for different activities and finding adequate areas in which to carry out the activities. I also had to teach bilingual classes.

Again, I was not observed or evaluated in any way. When the year wrapped up, I was given the same rating as the year before. Before the summer break, a new monster reared its head: Reduction in Force (RIF). It meant that, due to the lack of funds, school districts could terminate any personnel without cause. The administration threw this concept around at every opportunity. I figured that my days were numbered. RIF didn't materialize, and not a single person lost a job. It was a ploy to keep teachers in line. There was a lot of that going on in those days.

The next year, I dreaded going through the same thing that I had been through the year before. I had no desire to teach physical education again. Luckily for me, the state education department had stepped in and told

the administration that teachers not certified for the areas that they were assigned to were not to teach in those areas. I was once again assigned to a regular classroom, which was fine with me. The problem now was that I was assigned all of the troublemakers. Remembering that I had been labeled a troublemaker, I was determined to work with these kids and do my best to bring out the best in them. The year turned out very well. The students, although a little rowdy, accomplished more intellectual and behavior improvement than they had previously. Their parents were full of praise, and that meant more to me than the "satisfactory" rating that I received on my non-evaluated evaluation.

Before the next school year, the principal retired. I had earned my administrative certification and a master's degree. I applied for the position. I was quite certain that I would not be appointed, but the experience of applying and perhaps going through the interview process would be beneficial later on. As the process went on and I was called in for an initial interview, my confidence began to build up. After learning the names of the other candidates, my confidence soared. I felt I was the most qualified applicant. Before the hiring took place, my brother Joe and I were at a ballgame and in walked the superintendent with one of the other applicants. Joe turned to me and said, "There is the next principal." Still, my confidence was not shaken. Two weeks later, the new principal was appointed. Joe's prediction had been correct. Shaken but undaunted, I couldn't believe that the administration could be that unjust. Many of the classroom teachers had told me that they felt I was the best candidate and the administration had appointed not based on qualifications but on favoritism.

The newly appointed principal was a pushy, rude, macho individual. His manner was very demeaning toward female teachers. The ratio of female teachers to male teachers was about twenty-five to one, so he was very intimidating to the majority of the teaching staff. That did not pose a problem for me. I found that he, for some reason or the other, was afraid of me. Whether it was my aggressiveness or my reputation that intimidated him, I did not know. At any rate, the entire time that I was under his supervision, I could do my work as I desired. Almost from his arrival, I became his unofficial assistant, taking charge of the building in his absence. That afforded me experience I felt would be beneficial the next time that an administrative position became available. I was wrong.

In the years ahead, many positions became available. I submitted an application every time, and every time, I was passed over for a less qualified person. Yet I was determined to bring equality into the hiring process. I

continually confronted the administration, demanding that more Hispanic teachers be employed. The argument that the administration presented was that they were employing Hispanic people. Indeed they were—they were employing janitors, cooks, teachers' aids and other support staff but not enough teachers. My demands were that the percentage of teachers equal the percentage of the Hispanic population of the community. That would have been 40 percent at that time. The administration was steadfast in its refusal of my demands. As for me ever hoping to receive a principal's position—I felt that because of my stand on equality, I had sealed my fate and would remain in the classroom throughout my tenure with the Portales schools. This I was prepared to do.

The reason for my not being assigned a position as principal was not at this time based on nationality but on my aggressiveness in confronting the administration with my demands to equal employment of minorities. The system had changed superintendents due to retirements. The final straw came when the then superintendent appointed an individual that I felt was grossly incompetent. I felt that the appointment had been based on religious association rather than academic qualifications. That appointee lasted two years, and the discontent of the faculty finally got him fired.

Finally, after that appointment, I became totally dissatisfied with the progress of the implementation of the court-ordered changes. I approached the superintendent and demanded to review my personnel file. I was curious about what might be there. The superintendent told me that I could not have access to my file. I told him that I had every right to inspect my own file and that if I was not allowed to see it, I would get legal counsel. He then told me that I could see it, but he had to have time to remove any confidential documents that might be in it. The next day, I went in and he produced an empty folder. Every document had been purged. I asked him where all my evaluations and reference letters were. He had no response.

The following day, I presented him with a letter requesting to be put on the agenda so that I may address the Portales board of education. He said that I had no reason to address the board. I told him that I was in the process of filing a legal action against the school district. He became very angry but told his secretary to put me on the agenda.

The district had sporadically hired a few Hispanic teachers and one Hispanic principal. The one Hispanic principal was at Lindsey Elementary, later called Lindsey Middle School. The majority of Hispanic teachers were not aware of my efforts, and some of them turned against me. The battle I was fighting, I was fighting alone. Several times I was admonished by my

building principal and told to quit making waves. Had he not been afraid of me, I am sure that he would have fired me.

I was placed on the agenda to address the board. Before the date of the board meeting, I contacted several federal agencies: the Office of Civil Rights (OCR), League of United Latin American Citizens (LULAC) and the American GI Forum. OCR began an investigation and sent an associate to be present at the meeting. I contacted the nearest television station, and it sent a film crew to the meeting. The meeting was called to order and the superintendent and board were surprised to see the television camera in the room. When the time came for me to address the board, the camera began rolling. I delivered a thirty-minute prepared speech. When I was finished, there was a standing ovation from the crowded boardroom. The stunned board called for recess and immediately went into closed session. After an hour in closed session, the board members came back to open session and sided with the superintendent. The LULAC representative was not pleased that the media had been called in, and he made a hasty retreat.

The Office of Civil Rights representative, on the other hand, told me that OCR's investigation had found that my allegations had merit, and the OCR was stepping in to monitor the Portales schools to ensure that the mandate of the court was implemented totally. A month later, the Portales school board was told that the district was to be under the supervision of the OCR until further notice. The OCR began monitoring the system and would continue to do so for a period of five years, at which time a reassessment would take place. If all aspects had not been remedied, the monitoring would continue and the loss of federal funding might result. Several months later, the superintendent resigned, citing "preservation of his mental health" as the reason for his resignation.

The following is the text of the speech that I prepared and delivered to the Portales Municipal Schools Board of Education:

August 10, 1993
Ladies and gentlemen of the board, I want to express my appreciation to you for allowing me to be placed on the agenda and to address you here tonight.

It is with extreme reservations that I requested this audience, but I felt that it was time to address a situation that has been fostered in the Portales Municipal School System by past administrations and nurtured by the present administration. I have lived with this situation throughout my life, beginning as a student in the system and continuing in my career as an educator.

A History

I began teaching in the Portales Schools approximately twenty years ago. I felt at that time that I, having entered a profession that was meant to teach and dispel ignorance, would be treated as an equal among others in the same profession. This has not been the case. Having become a teacher gave me the incentive to continue my self-improvement and education so that I might advance in my chosen profession.

My first attempt to become an administrator was in 1979, when a vacancy was created upon the retirement of Mr. Morris Wood. I felt then as I do now that I was qualified for the position. I was interviewed and felt very good about my interview and felt a remote possibility that I would be nominated. I was not, but I decided that the person selected was more experienced and perhaps better qualified than I.

Since that time, I have applied for administrative positions in the Portales schools and have had a total of eight rejections. In each case, I accepted the decisions of the administration, thinking that perhaps their choice was the best candidate. I felt that with more experience, I would be the best candidate. This has not happened for me, nor for any other Hispanic educator in the system, save one who was appointed principal and proved to be so good that she was soon appointed to a position in the central administrative office. When Mrs. Valdez was appointed principal of Lindsey School, I did not apply for the position because I felt that she was the better candidate.

Ladies and gentlemen, I have exhausted every avenue of hope. I find that regardless of the efforts that I, and others like me, have made, we are systematically denied positions outside the classroom. As recently as this past week, I had still maintained confidence in the system. I still felt that the system would be fair. This was not the case.

Ladies and gentlemen, there has been in the past and there is now in the Portales schools an element of discrimination. Discrimination that has completely discouraged any non-Anglo candidates from applying for those positions. Sure the [superintendent] will maintain that everybody is given the same opportunity. If so, why then are there only two non-Anglo administrators in the whole system? The director of federal projects and an assistant principal at the junior high. The [superintendent] will maintain that candidates are interviewed by their peers and the successful candidate is selected from their recommendation. Does he not realize that it is he that must put an end to this discrimination? The way the system is now presents an attitude of tokenism and tokenism is the worse type of discrimination on earth.

I recently called another viable candidate for principal, Mr. Ray Gonzales, and asked him if he had been interviewed and his response was, "I didn't even apply because I knew what was going to happen."

Ladies and gentlemen, in a few moments I am sure you are going to go into a closed session and the name of a candidate will be recommended to you. That name will not be mine. The name that you will be given has already been introduced as the principal to the staff at the school. The [superintendent] *will defend his selection and do his very best to convince you that his selection was the right one. He has to; he has already awarded the position. I pray the board reconsider his recommendation and end this practice of discrimination here tonight. Because end it will. If not here tonight, then it will end in the halls of the judicial system of our beloved nation. I am through turning the other cheek. I will attempt to rally the community and Hispanic population for their support. Their support will be appreciated, but with it or without it, I will carry the fight to my dying breath, not for myself but for those that come after me, those students that I teach and try to set an example for, those students that will someday be sitting where you are tonight.*

The [superintendent] *has maintained that perhaps previous experience might be a factor in filling these positions. I would remind the board that Mr. Fowler had no previous administrative experience prior to being hired as assistant principal of Portales High School and later as director of instruction and even later as assistant superintendent. Mr. David Brooks—former principal at Brown Elementary School, James Elementary School and now at the New Valencia Elementary School—had no previous administrative experience when he was hired. Mr. Brian Arnold—former principal of Brown Elementary School, now director of instruction, soon to be named assistant superintendent—had no previous administrative experience prior to being hired. Mr. David Jenkins—former principal of Portales Junior High School, presently principal of Portales High School—had no previous administrative experience prior to being hired. Mrs. Sondra Hugg, principal of Lindsey (Middle) School, had no prior administrative experience. In fact, no present administrator other than the* [superintendent] *had administrative experience prior to being hired.*

If you believe that it is too late to rescind the position that has been awarded, let me point out that there is a person in the audience who was awarded a position only to have it snatched from him on the basis of an anonymous letter. Ladies and gentlemen of the board, I am no anonymous letter. I stand before you in an effort to correct an injustice

that has been perpetuated in the Portales School System for over half a century.

I surely believe that I have complied with all procedural requirements before seeking to address the board.

I find it only fair to advise you that I have been in contact with the United States Justice Department and have talked with Mr. Richard Sambrano of that office. I have also been in contact with the Human Rights Commission. My reasons for doing so is that, because at about this time last year, I was met with this same situation and I requested a meeting with the [superintendent] and the assistant superintendent. At that time, I requested to see my personnel file. I was denied that right, with the explanation by that there might be something confidential in my file that I might not be allowed to see. I accepted his decision without question. This last week, I submitted that same request in writing and I was allowed to see and obtain copies of my file. However, all letters of reference on my behalf had been deleted or had never been placed in my file in the first place. I feel that I, and others like me, have been the victim of unjust discrimination.

Thank you for allowing me to speak, and may your wisdom lead you to make the correct decision.

I continued my teaching career with considerable success in the classroom. I retired in 1999, completing twenty-five years in the educational system. During that tenure, I was never formally evaluated by an administrator. One principal observed my teaching technique for fifteen minutes. My lesson plans, though readily available, were never inspected. Upon my retirement, the percentage of Hispanic employees in the Portales schools was over 45 percent, equal or more than the total percentage of the Hispanic population of the community. I felt that my goal had been accomplished. After I retired, I was approached by several educators who felt that they had been treated unfairly by the system. I decided that my days of activism were over and that it would have to be somebody else to carry the torch.

The history of the Hispanics who, seventy plus years ago, were workers brought to the Portales area with little other than the clothes on their backs has evolved to a history rich in success. That small group of people with little education had a strong desire to become productive citizens. In the intervening years, the sons and daughters of that group have carried on.

Very few of us who arrived on that truck so many years ago are still here. Most of the elders have passed on to their just rewards. The present

descendants of those families have in the past and at present continued to achieve. Orlando Ortega Jr. became a very productive mayor of the city of Portales. Jake Lopez and his sons have occupied offices on the city council as well as on the county commission. Alfredo Bachicha, Antonio Salguero, Robert Garcia and others have held positions in local government. Many of them have become educators with advanced degrees. Others have built businesses of all types, from building contractors to merchants. Some returned to their roots and became farmers. Regardless of the routes they chose, they wear their titles with pride.

In later years, with the advent of the dairy industry in the Portales area, other Hispanic laborers have migrated to the area. Most of these newcomers are from South Texas and even Mexico. This history is not about them. Although they are hardworking people, they did not have to endure the hardships of striving to be accepted by a population who felt their way of life was being infringed on.

Wrapping up my tale, I would like to say that in this narrative, I have never mentioned two words: racism or prejudice. Those two words have never existed in my vocabulary. I believe that in the area where this adventure took place, there was neither of these elements. I do believe that there were two peoples, each misinformed and suspicious of the other. Only time could (and did) dissolve the mistrust. Knowledge of each other's customs and beliefs brought about trust and equality. Two cultures merged into one, and peace and harmony prevailed.

Unlike other conflicts between cultures and people of different races and nationalities, we did not have a Rosa Parks. If we had, there were no buses on which to protest. We had no Dr. Martin Luther King Jr. with whom to march on state or national capitals. We had no Caesar Chavez to protest in the fields. Indeed, all we had was a desire to work and live in a society different from ours, a society into which we were introduced by need. Our desire to achieve enabled us to set and reach goals. Transition was slow, but in the long run, we persevered. I know that there will be some that will find fault with what I have written. That is their right.

EPILOGUE

Abel and Soledad Trujillo, my parents, along with my brothers Abel Trujillo Jr. and George Trujillo, died and are interred at the northeast

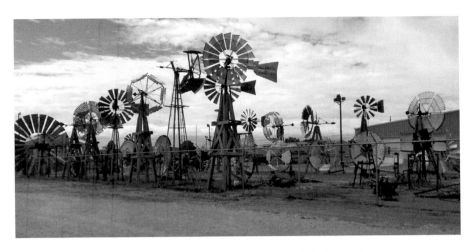

Dalley Windmill Collection donated to Roosevelt County. *Author's collection.*

corner of the Portales Cemetery—less than one hundred yards from the site of the granary that was our first housing unit in Portales and Roosevelt County.

Appendix

499 F2d 1147 *Serna v. Portales Municipal Schools*

Judy SERNA, a minor through her parent and general guardian, Romana Serna, et al., plaintiffs-appellees, v. PORTALES MUNICIPAL SCHOOLS et al., Defendants-Appellants.
No. 73-1737.
United States Court of Appeals, Tenth Circuit.
Argued March 20, 1974. Decided July 17, 1974.
Charles A. Pharris, Albuquerque, N.M., for defendants-appellants.
Vilma S. Martinez, San Francisco, Cal. (Sanford Jay Rosen, Alan B. Exelrod, and Michael A. Mendelson, San Francisco, Cal., David W. Bonem, Clovis, N.M., Dan Sosa, Jr., Las Cruces, N.M., on the brief), for plaintiffs-appellees.
C. Emery Cuddy, Jr., Santa Fe, N.M., for amicus curiae State Bd. of Ed.
Before HILL and McWILLIAMS, Circuit Judges, and DURFEE,* Judge.
HILL, Circuit Judge.

1. Appellees in this class action are Spanish-surnamed Americans seeking declaratory and injunctive relief against Portales Municipal School District for alleged constitutional and statutory violations committed under color of state law. In particular, appellees contend that appellant-school district has deprived them of their right to equal protection of the laws as guaranteed by the Fourteenth Amendment to the United States Constitution and of their statutory rights under Title VI of the

1964 Civil Rights Act, specifically 601, 42 U.S.C. 2000d. Jurisdiction is invoked under 28 U.S.C. 1343.

2. Pertinent facts include the following: the City of Portales, New Mexico, has a substantial number of Spanish-surnamed residents. Accordingly, a sizable minority of students attending the Portales schools are Spanish surnamed. Evidence indicates that many of these students know very little English when they enter the school system. They speak Spanish at home and grow up in a Spanish culture totally alien to the environment thrust upon them in the Portales school system. The result is a lower achievement level than their Anglo-American counterparts, and a higher percentage of school dropouts.

3. For the 1971–72 school year, approximately 34 percent of the children attending Portales' four elementary schools, Lindsey, James, Steiner and Brown, were Spanish surnamed. The junior high school and senior high school enrollments of Spanish-surnamed students were 29 percent and 17 percent, respectively. Unquestionably as Spanish-surnamed children advanced to the higher grades a disproportionate number of them quit school.

4. Appellees in their complaint charge appellant with discriminating against Spanish-surnamed students in numerous respects. Allegedly there is discrimination in appellants' failure to provide bilingual instruction which takes into account the special educational needs of the Mexican-American student; failure to hire any teachers of Mexican-American descent; failure to structure a curriculum that takes into account the particular education needs of Mexican-American children; failure to structure a curriculum that reflects the historical contributions of people of Mexican and Spanish descent to the State of New Mexico and the United States; and failure to hire and employ and administrators including superintendents, assistant superintendents, principals, vice-principals, and truant officers of Mexican-American descent. This failure to provide equal educational opportunities allegedly deprived appellees and all other similarly situated of their right to equal protection of the laws under the Fourteenth Amendment.

5. At trial appellees presented the following evidence to support their allegations. United 1970 none of the teachers in the Portales schools was Spanish surnamed, including those teaching the Spanish language in junior and senior high school; there had never been a Spanish-surnamed principal or vice-principal and there were no secretaries who spoke Spanish in the elementary grades.

6. Evidence was offered showing that in 1969 the report by Portales Municipal Schools to United States Commission on Civil Rights indicated

that at Lindsey, the 86 percent Spanish surnamed school, only four students with Spanish surnames in the first grade spoke English as well as the average Anglo first grader. During an evaluation of the Portales Municipal Schools by the New Mexico Department of Education in 1969, the evaluation team concluded that the language arts program at Lindsey School "was below average and not meeting the needs of those children." Notwithstanding this knowledge of the plight of Spanish-surnamed students in Portales, appellants neither applied for funds under the federal Bilingual Education Act, 20 U.S.C. 880b, nor accepted funds for a similar purpose when they were offered by the State of New Mexico.

7. Undisputed evidence shows that Spanish-surnamed students do not reach the achievement levels attained by their Anglo counterparts. For example, achievement tests, which are given totally in the English language, disclose that students at Lindsey are almost a full grade behind children attending other schools in reading, language mechanics and language expression. Intelligence quotient tests show that Lindsey students fall further behind as they move from the first to the fifth grade. As the disparity in achievement levels increases between Spanish-surnamed and Anglo students, so does the disparity in attendance and school dropout rates.

8. Expert witnesses explained what effect the Portales school system had on Spanish-surnamed students. Dr. Zintz testified that when Spanish-surnamed children come to school and find that their language and culture are totally rejected and that only English is acceptable, feelings of inadequacy and lowered self-esteem develop. Henry Pascual, Director of the Communicative Arts Division of the New Mexico Department of Education, stated that a child who goes to a school where he finds no evidence of his language and culture and ethnic group represented becomes withdrawn and nonparticipating. The child often lacks a positive mental attitude. Maria Gutierrez Spencer, a longtime teacher in New Mexico, testified that until a child developed a good self-image not even teaching English as a second language would be successful. If a child can be made to feel worthwhile in school then he will learn even with a poor English program. Dr. Estevan Moreno, a psychologist, further elaborated on the psychological effects of thrusting Spanish-surnamed students into an alien school environment. Dr. Moreno explained that children who are not achieving often demonstrate both academic and emotional disorders. They are frustrated and they express their frustration in lack of attendance, lack of school involvement and lack of community involvement. Their frustrations are reflected in hostile behavior, discipline problems and eventually dropping out of school.

9. Appellants' case centered around the testimony of L.C. Cozzens, Portales' superintendent of schools. Cozzens testified that for the 1971–72 school year out of approximately 80 applications for elementary school teaching positions only one application was from a Spanish-surnamed person. Nevertheless, through aggressive recruiting Portales hired six Spanish-surnamed teachers. At Lindsey a program was established to teach first graders English as a second language; and with the aid of federal funds a program was also established to serve the needs of pre-school Spanish-surnamed children. At the high school level an ethnic studies program was initiated which would be directed primarily at the minority groups and their problems.

10. The faculty was encouraged to attend workshops on cultural awareness. Altogether over a third of the entire faculty attended one or more of these workshops.

11. After hearing all evidence, the trial court found that in the Portales schools' Spanish-surnamed children do not have equal educational opportunity and thus a violation of their constitutional right to equal protection exists. The Portales School District was ordered to:

12. reassess and enlarge its program directed to the specialized needs of its Spanish-surnamed students at Lindsey

13. and also to establish and operate in adequate manner programs at the other elementary schools where no bilingual-bicultural program now exists.

14. Defendant school district is directed to investigate and utilize whenever possible the sources of available funds to provide equality of educational opportunity for its Spanish-surnamed students.

15. It is incumbent upon the school district to increase its recruiting efforts

16. if those recruiting efforts are unsuccessful, to obtain sufficient certification of Spanish-speaking teachers to allow them to teach in the district.

17. Appellants, in compliance with the court's order to submit a plan for remedial action within 90 days, thereafter filed a proposed plan. In essence the plan provided bilingual education for approximately 150 Lindsey students in grades one through four. Each group would be given instruction in Spanish for approximately 30 minutes daily. A Title VII bilingual program would be instituted for approximately 40 pre-school children. Practically all personnel employed for this program would be Spanish surnamed. At the junior high one Spanish-surnamed teacher aide would be employed to help Spanish-surnamed children experiencing difficulty in the language arts. At the high school a course in ethnic studies would be offered emphasizing minority cultures and their contribution to society. In connection with this program appellants applied to the State Department of Education for state bilingual

funds. These funds would provide one bilingual-bicultural instructor for the school district's other three elementary schools, and one bilingual-bicultural teacher or teacher aide at the junior high school. Seeking other sources of funding was also promised as long as the control and supervision of the programs remained with the local board of education.

18. Although complying with most of the court's order, appellants noted that because enrollment is declining in the Portales schools there would be fewer teachers employed next year. Thus, very likely there would not be any positions to be filled. If a position becomes vacant, however, the school district promised to make every reasonable effort to secure a qualified teacher with a Spanish surname.

19. Appellees thereafter filed a Motion for Hearing to hear appellees' objections to appellants' program. The motion was granted and at the hearing, after stating their objections to appellants' proposed plan, appellees introduced their own proposed bilingual-bicultural program. After reviewing both parties' programs, the trial court entered final judgment, adopting and adding the following to its prior memorandum opinion:

I. Curriculum
A. Lindsey Elementary
20. All students in grades 1–3 shall receive 60 minutes per day bilingual instruction. All students in grades 4–6 shall receive 45 minutes per day bilingual instruction. These times are to be considered a minimum and should not be construed to limit additional bilingual training (i.e. the Title III self contained classroom for first graders with special English language problems).

21. A testing system shall be devised for determining the adequacy of the above established time periods with ensuing adjustments (either an increase or decrease in bilingual instruction) as needed.

B. James, Steiner and Brown Elementary
22. All Spanish-speaking students in grades 1–6 shall receive 30 minutes per day of bilingual instruction. This program should be made available to interested non-Spanish speaking students as funding and personnel become available to expand the bilingual instruction.

23. A bicultural outlook should be incorporated in as many subject areas as practicable.

24. Testing procedures shall be established to test the results of the bilingual instruction and adjustments made accordingly.

C. Junior High

25. Students should be tested for English language proficiency and, if necessary, further bilingual instruction should be available for those students who display a language barrier deficiency. D. High School

26. An ethnic studies course will be offered in the 1973–74 school year as an elective. This course should be continued and others added in succeeding years.

27. The minimum curriculum schedule set forth in A through D above is not intended to limit other bilingual programs or course offerings currently available in the Portales school system or which will become available in the future.

II. Recruiting and Hiring.

28. A special effort should be made to fill vacancies with qualified bilingual teachers. Recruiting should be pursued to achieve this objective.

III. Funding

29. Defendants appear to have complied with the court's directive to investigate and utilize sources of available funding. Efforts should continue in seeking funding for present as well as future programs which will help achieve equality of educational opportunities for Spanish-surnamed students.

30. Appellants promptly appealed, positing two grounds for reversal. First, appellants suggest that appellees neither have standing nor are suitable parties under Rule 23 to maintain this suit as a class action; second, that failure to afford a program of bilingual instruction to meet appellees' needs does not deny them equal protection of the law when such needs are not the result of discriminatory actions.

31. Appellants' first argument is that appellees are not suitable parties under Rule 23 to maintain this suit as a class action. In particular, appellants argue that appellees have failed to show that there are questions of law or fact common to the alleged class and that the claims of the representative parties are typical of the claims or defenses of that class. We disagree. National origin discrimination in equal educational opportunities is the alleged basis for this lawsuit. As the complaint and supporting evidence point out, 26 percent of the Portales school population are Spanish surnamed. Nevertheless, prior to the lawsuit there were no Spanish-surnamed board of education members, teachers, counselors, or administrators. Nor was any attempt made by Portales school personnel to provide for the educational needs of Spanish-

surnamed children. These allegations clearly raise questions common to the class which appellees represent and are typical of the claims of that class. We therefore are convinced that appellees fully meet the rigid requirements of Rule 23 and thus properly filed this suit as a class action. *Bossier Parish School Bd. v. Lemon*, 370 F.2d 847 (5th Cir. 1967), cert. den'd, 388 U.S. 911, 87 S.Ct. 2116, 18 L.Ed.2d 1350.

32. Appellants also challenge appellees' standing to bring this suit because appellees have failed to show a personal stake in the outcome of this action. We cannot agree; the complaint was filed by parents of school age children and the Chicano Youth Association. Each minor child is allegedly a student in the Portales schools or was excluded therefrom. The complaint alleges that those and all Spanish-surnamed school children have been subject to discrimination by the school district. We believe appellees have satisfactorily alleged that appellants' discriminatory actions caused them injury in fact and hence they have standing to sue. *Flast v. Cohen*, 392 U.S. 83, 88 S.Ct. 1942, 20 L.Ed.2d 947 (1968); *Baker v. Carr*, 369 U.S. 186, 82 S.Ct. 691, 7 L.Ed.2d 663 (1962); *Bossier Parish School Bd.*, supra.

33. Appellants next challenge the district court's holding that the Portales municipal schools denied appellees equal protection of the law by not offering a program of bilingual education which met their special educational needs. In light of the recent Supreme Court decision in *Lau v. Nichols*, 414 U.S. 563, 94 S.Ct. 786, 39 L.Ed.2d 1 (1974), however, we need not decide the equal protection issue. *Lau* is a case which appellants admit is almost identical to the present one. In *Lau* non-English speaking Chinese students filed a class suit against the San Francisco Unified School District. The facts showed that only about half of the 3,457 Chinese students needing special English instruction were receiving it. The Chinese students sought relief against these unequal educational opportunities which they alleged violated the Fourteenth Amendment. The district court denied relief, and the Court of Appeals affirmed, holding that there was no violation of the equal protection clause of the Fourteenth Amendment nor of 601 of the Civil Rights Act of 1964. The Supreme Court, without reaching the equal protection clause argument but relying solely on 601 of the Civil Rights Act of 1964, 42 U.S.C. 2000d, reversed the Court of Appeals.

34. The Supreme Court notes that the State of California requires English to be the basic language of instruction in public schools. Before a pupil can receive a high school diploma of graduation he must meet the standards of proficiency in English. A student who does not understand the English language and is not provided with bilingual instruction is therefore effectively

precluded from any meaningful education. The Court concludes that such a state imposed policy, which makes no allowance for the needs of Chinese-speaking students, is prohibited by 601. The reason for this is that 601 bans discrimination based "on the ground of race, color, or national origin" in "any program or activity receiving Federal financial assistance." In reaching its conclusion the Court relies heavily upon HEW regulations that require school systems to assure that students of a particular national origin are not denied the opportunity to obtain the education generally obtained by other students in the system. In particular the Court noted that HEW has ordered school systems to take remedial steps to rectify language deficiency problems.

35. Where inability to speak and understand the English language excludes national origin-minority group children from effective participation in the educational program offered by a school district, the district must take affirmative steps to rectify the language deficiency in order to open its instructional program to these students. 35 Fed.Reg. 11595 (1970).

36. Finally, the Court reasons that because the San Francisco school district contractually agreed to comply with Title VI of the 1964 Civil Rights Act and all HEW regulations, the federal government can fix the terms on which its money allotments to that district will be disbursed. The case was accordingly remanded to the Court of Appeals for the fashioning of appropriate relief.

37. As noted above, the factual situation in the instant case is strikingly similar to that found in *Lau*. Appellees are Spanish-surnamed students who prior to this lawsuit were placed in totally English speaking schools. There is substantial evidence that most of these Spanish-surnamed students are deficient in the English language; nevertheless no affirmative steps were taken by the Portales school district to rectify these language deficiencies.

38. The trial court noted in its memorandum opinion that appellees claimed deprivation of equal protection guaranteed by the Fourteenth Amendment and of their statutory rights under Title VI of the 1964 Civil Rights Act, specifically 601. While the trial court reached the correct result on equal protection grounds, we choose to follow the approach adopted by the Supreme Court in Lau; that is, appellees were deprived of their statutory rights under Title VI of the 1964 Civil Rights Act. As in *Lau*, all able children of school age are required to attend school. N.M.Const. Art. XII, 5. All public schools must be conducted in English. N.M.Const. Art. XXI, 4. While Spanish-surnamed children are required to attend school, and if they attend public schools the courses must be taught in English, Portales school district has failed to institute a program which will rectify language

deficiencies so that these children will receive a meaningful education. The Portales school curriculum, which has the effect of discrimination even though probably no purposeful design is present, therefore violates the requisites of Title VI and the requirement imposed by or pursuant to HEW regulations. *Lau*, supra.

39. Appellants argue that even if the school district were unintentionally discriminating against Spanish-surnamed students prior to institution of this lawsuit, the program they presented to the trial court in compliance with the court's memorandum opinion sufficiently meets the needs of appellees. The New Mexico State Board of Education (SBE), in its Amicus Curiae brief, agrees with appellants' position and argues that the trial court's decision and the relief granted constitute unwarranted and improper judicial interference in the internal affairs of the Portales school district. After reviewing the entire record we are in agreement with the trial court's decision. The record reflects a longstanding educational policy by the Portales schools that failed to take into consideration the specific needs of Spanish-surnamed children. After appellants submitted a proposed bilingual-bicultural program to the trial court a hearing was held on the adequacies of this plan. At this hearing expert witnesses pointed out the fallacies of appellants' plan and in turn offered a more expansive bilingual-bicultural plan. The trial court thereafter fashioned a program which it felt would meet the needs of Spanish-surnamed students in the Portales school system. We do not believe that under the unique circumstances of this case the trial court's plan is unwarranted. The evidence shows unequivocally that appellants had failed to provide appellees with a meaningful education. There was adequate evidence that appellants' proposed program was only a token plan that would not benefit appellees. Under these circumstances the trial court had a duty to fashion a program which would provide adequate relief for Spanish-surnamed children. As the Court noted in *Swann v. Charlotte-Mecklenburg Board of Education*, 402 U.S. 1, 15, 91 S.Ct. 1267, 1276, 28 L.Ed.2d 554 (1971), "once a right and a violation have been shown, the scope of a district court's equitable powers to remedy past wrongs is broad, for breadth and flexibility are inherent in equitable remedies." Under Title VI of the Civil Rights Act of 1964 appellees have a right to bilingual education. And in following the spirit of *Swann*, supra, we believe the trial court, under its inherent equitable power, can properly fashion a bilingual-bicultural program which will assure that Spanish-surnamed children receive a meaningful education. See also *Green v. School Bd.*, 391 U.S. 430, 88 S.Ct. 1689, 20 L.Ed.2d 716 (1968); *Brown v.*

Bd. of Education (II), 349 U.S. 294, 75 S.Ct. 753, 99 L.Ed. 1083 (1955). We believe the trial court has formulated a just, equitable and feasible plan; accordingly we will not alter it on appeal.

40. The New Mexico State Board of Education stresses the effect the decision will have on the structure of public education in New Mexico. It is suggested that bilingual programs will now be necessitated throughout the state wherever a student is found who does not have adequate facility in the English language. We do not share SEB's fears. As Mr. Justice Blackmun pointed out in his concurring opinion in *Lau*, numbers are at the heart of this case and only when a substantial group is being deprived of a meaningful education will a Title VI violation exist.

* Honorable James R. Durfee, United States Court of Claims, sitting by designation.[5]

Notes

1. Jean M. Burroughs, ed., *Roosevelt County History and Heritage* (Portales, NM: Bishop, 1975), 285.
2. James W. Loewen, *Sundown Towns: A Hidden Dimension of American Racism* (N.p.: Touchstone, 2006).
3. Compiled by J.R.Spencer, *New Mexico Digest* (1978): 122.
4. José Ortiz y Pino III, *Don José: The Last Patrón* (Santa Fe, NM: Sunstone Press, 2007).
5. *Serna v. Portales Municipal Schools, et al.*, 499 F.2d 1147, (10th Cir. 1974). http://openjurist.org/499/f2d/1147.

About the Author

Agapito "Pete " Trujillo was born in Palma, New Mexico, on February 19, 1937. When he was very young, his family relocated to Encino, New Mexico, for a short period of time. Because of economic necessity, the family became farm workers and migrated to the plains of eastern New Mexico. It is there that this adventure took place.

Author's collection.